THE WORLD OF FAERY

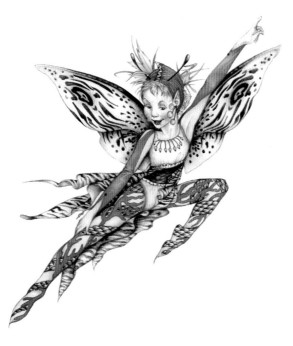

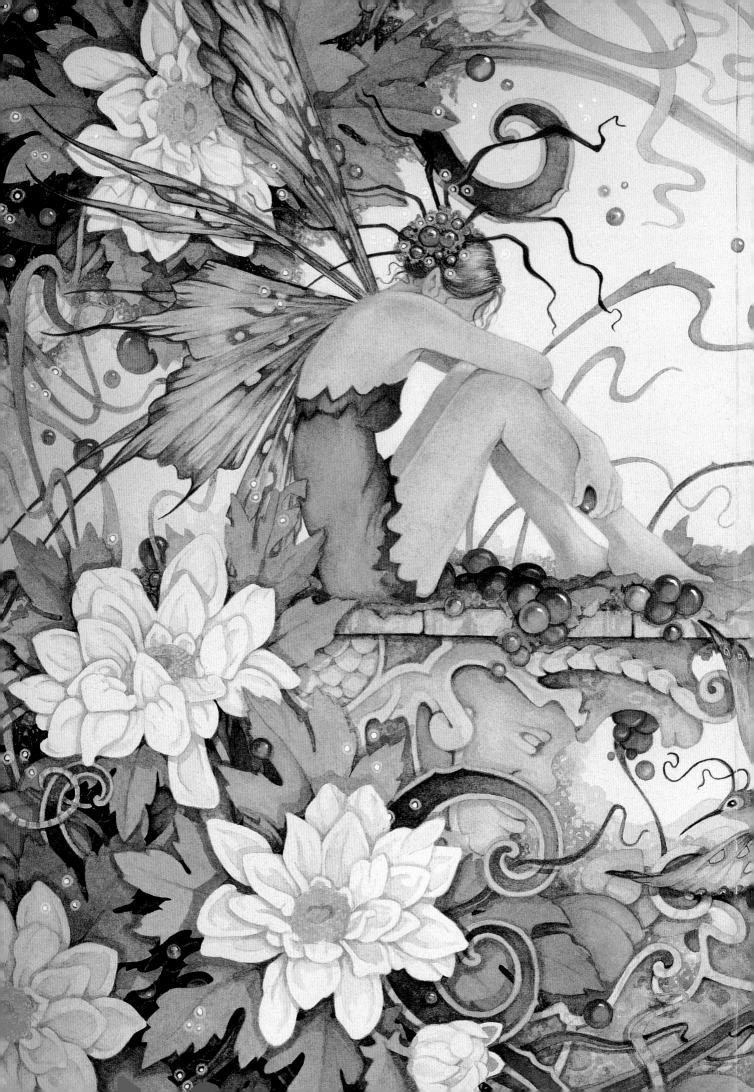

THE WORLD OF FAERY

AN INSPIRATIONAL COLLECTION OF ART
FOR FAERY LOVERS

~~~~~~~

### PRESENTED BY DAVID RICHÉ

*For Owen and those whose lives have been touched by faeries, blessed be.*

First published in Great Britain in 2005 by
Paper Tiger
The Chrysalis Building
Bramley Road
London W10 6SP

An imprint of **Chrysalis** Books Group plc

Distributed in the United States and Canada by Sterling Publishing Co.
387 Park Avenue South, New York, NY 10016, USA

1 3 5 7 9 8 6 4 2

British Library Cataloguing-in-Publication Data:
A catalogue record for this book is available from the
British Library.

ISBN 1 84340 282 3

Designed by Malcolm Couch
Project managed by Miranda Sessions

Reproduction by Mission Productions Ltd.
Printed in China

Front Cover: Amy Brown *Luna Sprite*
Back Cover: Josephine Wall *Sadness of Gaia*
Front flap: Scott Grimando *Chameleon Fairy*
Back flap: Renee Biertempfel *Wood Faery*
Page 1: Myrea Pettit *Leaping Fairy*
Pages 2–3: Linda Ravenscroft *Mystic Garden*
Page 4: Hazel Brown *Wood Sprite*
Page 112: Marja Lee Kruÿt *Jes*
(Kindly provided although artist
does not feature.)

**A note on the spelling of 'fairy' 'faery'
and 'faerie'.**
Collins English Dictionary provides a
single entry for "Faerie or Faery"
and gives the following definitions:
Archaic or poetic.
1 the land of fairies.
2 enchantment. adj, n
3 a variant of fairy.
All three spelling have been used in this
book, in accordance with the preference
of the individual artists involved.

# THE WORLD OF FAERY

### AN INSPIRATIONAL COLLECTION OF ART
### FOR FAERY LOVERS

PRESENTED BY David Riché

*For Owen and those whose lives have been touched by faeries, blessed be.*

First published in Great Britain in 2005 by
Paper Tiger
The Chrysalis Building
Bramley Road
London W10 6SP

An imprint of **Chrysalis** Books Group plc

Distributed in the United States and Canada by Sterling Publishing Co.
387 Park Avenue South, New York, NY 10016, USA

1 3 5 7 9 8 6 4 2

British Library Cataloguing-in-Publication Data:
A catalogue record for this book is available from the British Library.

ISBN 1 84340 282 3

Designed by Malcolm Couch
Project managed by Miranda Sessions

Reproduction by Mission Productions Ltd.
Printed in China

Front Cover: Amy Brown *Luna Sprite*
Back Cover: Josephine Wall *Sadness of Gaia*
Front flap: Scott Grimando *Chameleon Fairy*
Back flap: Renee Biertempfel *Wood Faery*
Page 1: Myrea Pettit *Leaping Fairy*
Pages 2–3: Linda Ravenscroft *Mystic Garden*
Page 4: Hazel Brown *Wood Sprite*
Page 112: Marja Lee Kruÿt *Jes*
(Kindly provided although artist does not feature.)

**A note on the spelling of 'fairy' 'faery' and 'faerie'.**
Collins English Dictionary provides a single entry for "Faerie or Faery" and gives the following definitions:
Archaic or poetic.
1 the land of fairies.
2 enchantment. adj, n
3 a variant of fairy.
All three spelling have been used in this book, in accordance with the preference of the individual artists involved.

# CONTENTS

The Fairy Faithful
*Foreword by Alan Lee*  6

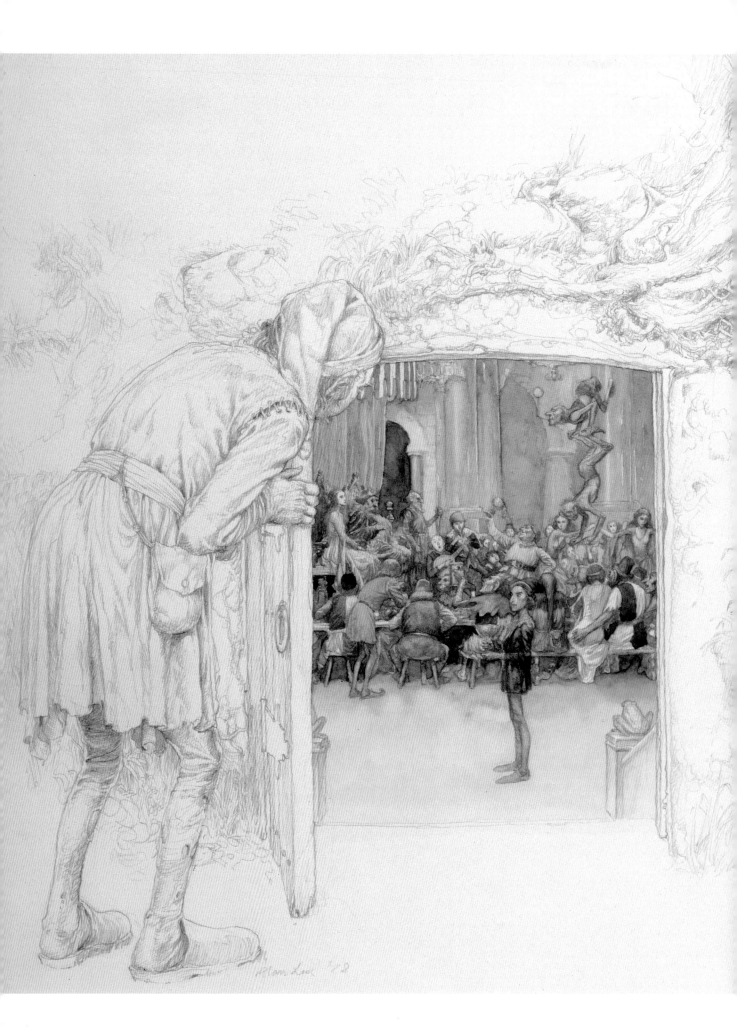

# THE FAIRY FAITHFUL

From the children of Danu to the Kappa of Japan, the Russian Rusalki to the Patupaiarehe of New Zealand, the multi-faceted shifting populace of faery has shadowed and haunted the human inhabitants of our world. Living lives that are a fey counterpoint to our own, often mimicking our follies and institutions, they offer us visions of a vast realm that lies between the stark polarities of heaven and hell, between received ideas of good and evil, and between our mundane world and what we are led to expect of it.

The faerie courts that celtic heroes stumble into are reflections of those of their own leaders, with the addition of magical treasures, outrageously extravagant décor (birds wings are frequently used as thatch) and a host of courtiers with a variety of supernatural qualities. The king of the fairies, whether he is the Dagda, or Gwyn ap Nudd, or Oberon, rules his otherworldy kingdom, not by the authority of god, but according to the more ambivalent laws of nature, leavened with the perversity of the trickster. And he, in turn, is ruled by his Queen, because she embodies the earth and its ancient powers.

Dana, Titania, Mab, Morgana, Gloriana; each age creates her anew. The Queen of Elfland who spirited True Thomas away from his life in thirteenth century Scotland returns him to the world as a seer, a useful career move in such turbulent times. His verses and the prophesies of Merlin and Taliesin were popular and widely consulted long after they were originally penned. Spenser's *Faerie Queen* is a flattering portrait of his own monarch, Elizabeth the first, while the allegorical knights that serve her can be identified as fellow courtiers. Shakespeare's audience was completely familiar with the idea that the woodlands are home to a multitude of playful, and at times malevolent beings. The Fays and enchantresses in the work of nineteenth-century poets such as Tennyson, William Morris, Sir Walter Scott and W B Yeats are ancient deities invoked to help define an age on the verge of change. Romance, mythologising, and the

� *Fairy Hill*
*12½ x 9½ inches. Watercolour and pencil.*

*Titania*                           ⋯
*12 x 8 inches. Pencil.*

recovery of folklore are a common accompaniment to nation building and political aspiration, just as a loss of those traditions is a sign of decay and despair.

The Faerie queen brought into being in the darkest years of the twentieth century is the lady of Lothlorien, Galadriel, in J. R. R. Tolkien's *The Lord of the Rings*. She is a beacon of hope to the fellowship; a revealler of truths, and an embodiment of the benign powers of nature, and in particular, of the forest. Most tellingly, she declines to take the one ring for herself, knowing that true change will not come from the exercise of power, but from the courage and the imagination of the least powerful.

Although she and all the other queens of faerie embody nature, their role is not simply to be guardians of it, or symbols of it's inviolability. It is to ensure it's renewal, and they do this by challenging our imagination, whether it is by sending us white stags to lead us into adventure, or offering us glimpses into possible futures, revealed in a magical pool or fountain.

We need those challenges and visions as much now as we ever have, and we need to be tricked and beguiled as well. It is good to see that Puck and the Will o' the Wisp, as well as the regal allure of the high elves, are leading still more of us down the winding road to fair elfland, and to its hollow hills, enchanted woods, and sublime dreams.

*Alan Lee, Devon, August 2005.*

↩ **Luthian**
*12½ x 9½ inches. Watercolour.*

**Faerie Queen** ↪
*16½ x 12 inches. Pencil.*

# JOHN ARTHUR

OF ALL THE artistic and commercial commissions that John has worked on over the last 30 years, he has received more comment on his pen and ink faerie art than on anything else he's done. Of course, the watercolours get most of the attention because of the colour, so he's delighted to hear all the positive feedback. As a figurative artist John is constantly seeking new poses while revisiting old ones. His figures are extremely spontaneous; some drawn from the live model, some from imagination. He never erases pencil lines beneath the pen. "I enjoy watching the thinking process in other artist's work. It's interesting to compare the first response to the final". He's often asked about the mushrooms in his drawings; very organic and spontaneous natural shapes. These are all false memories of mushrooms – nothing real – and "a lot of fun to do."

John loves working in line. Line is his passion. He has studied and written about Line for years. He's examined the use of it from a mathematical concept to a metaphor in almost every aspect of our lives; as an illusion that we develop subconsciously as artists, to the seemingly three-dimensional effect that we attempt to create on the surface of paper. Our perception is developed and enhanced by the understanding of line and the fact that it does not exist until we create it. John belives it is no accident that history's greatest painters were also the greatest line artists. "Most people see this as a contradiction, but it is quite the contrary. There is a trend in painting that suggests that knowing how to draw hinders the process of painting." This is ignorance looking for an excuse not to study. Charlie Byrd didn't learn to play his horn with such original abstraction by not learning the basics. So John's advice to young artists is "Draw you fools!"

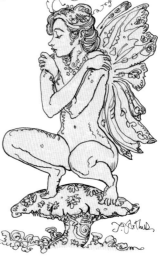

### Summer Snow
*9 x 12 inches. Pen and ink.*

The idea of snow in the summer is a favourite of mine. This faerie appears to be enjoying it. I also like the challenge of foreshortening in the legs.

### Titania's Dance
*14 x 18½ inches. Watercolour.*

This is my version of Shakespeare's Titania from *A Midsummer Night's Dream*. She's just finished her dance, and of course a faerie's dance is always magical. She looks up – and there you are – watching. I didn't use a model for this but simply sketched directly onto watercolour board. This often produces some of my best paintings.

*"John continually makes conscious attempts to alter his perception of reality through the way he sees the outside world."*

### Maureen
*10 x 16 inches. Pen and ink with gold wash.*

A very faeriesque feel and a resemblance of my wife. She did not pose for this but by now I have her pretty well memorized. My friends and family are continually seeing her in my paintings, even those I did before we met. There must be something to the ideal beauty theme after all.

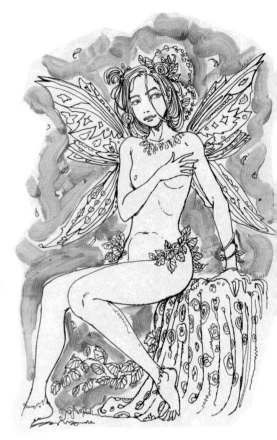

The greatest spiritual change in John's life came about this past year when his dear wife and soul mate of 15 years, Maureen, was diagnosed with inoperable cancer. "It has been an incredibly unbelievable time for us all. The love and support through family, friends, church and community has been amazing. The response from the artistic community was a wonderful blessing." This outpouring of love and encouragement has lifted everyone. John continually makes conscious attempts to alter his perception of reality through the way he sees the outside world. This experience has given John the opportunity to view the world in a way that he would never have seen before; an experience truly beyond words.

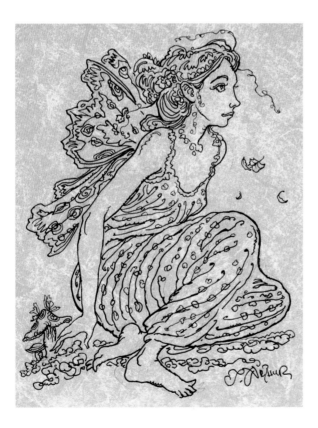

### Tandi
*8 x 9½ inches. Pen and ink.*

No model was used on this piece. Drawings like these are always my favourites. There's nothing in the way of the subconscious and the pen. I'm always excited to see what the end result will be. An artist should be in a constant state of surprise while creating.

### Aimee; Faerie of Light and Colour
*11 x 16¾ inches. Watercolour.*

I went wild with colour on this one. The face is a subconscious likeness of a fellow faerie artist, I'll let the fans guess which one. And she is named after a little friend and faerie who has been in all of our hearts this last year.

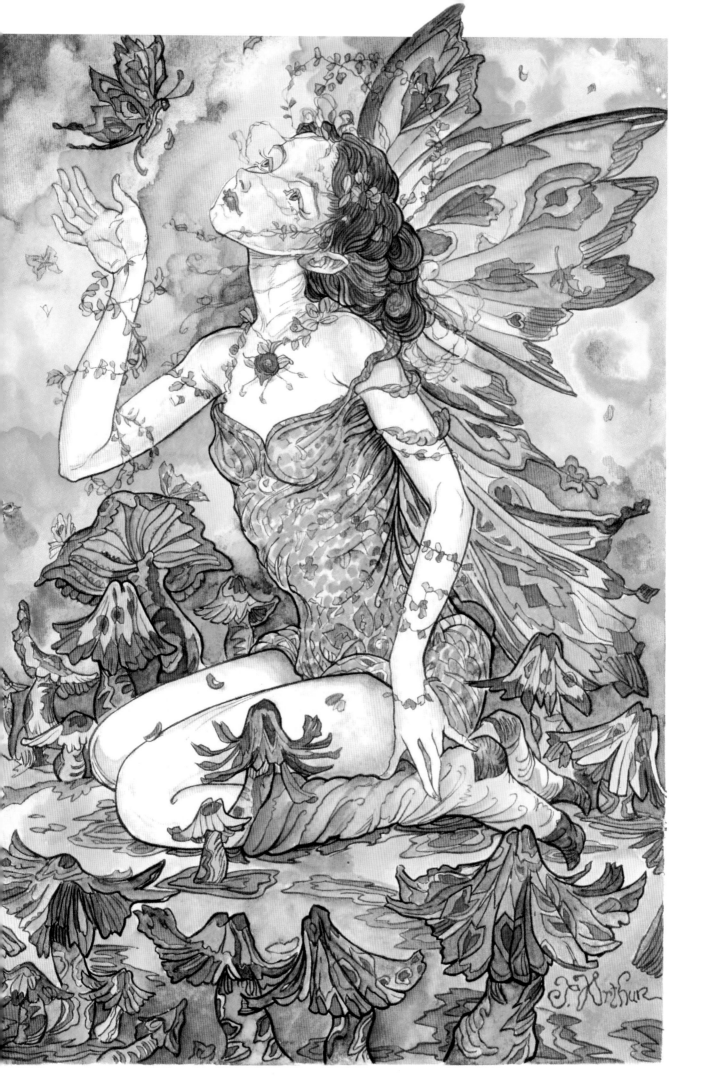

# JASMINE BECKET-GRIFFITH

BEING ABLE TO SHARE her vision, thoughts, and experiences is very important to Jasmine, helping her to progress as an artist and refine her style and technique. Two recent style changes are the expansion of Jasmine's palette to embrace more varied colour schemes, and gravitation towards larger paintings than in the past. Her work still focuses primarily on Faery, Fantasy, and Gothic themes, as well as commercial contracts for licensing of her images on products, plus a range of cards that will be marketed throughout the US, Canada and Europe. In addition to this she is now working on a new solo book.

Most of Jasmine's artwork is in acrylic paint on canvas. She has refined her technique and now uses fluid bottled paint with dozens, even hundreds, of thin layers of paint; starting with darker hues, building up with midtones and finally highlights – very much a 'glazing' technique. This gives her artwork an almost jewel-like shimmering look that is well suited to Faery themes. It is sometimes a repetitive, time-consuming way to paint, but as a perfectionist, she embraces it. Smoothness is important to her. There is very little *impasto* in any paintings, often simple glazes of paint and filtered tap water gives slight tints and graduations of colour. For flesh tones, and delicate fairy wings, Jasmine works horizontally to prevent any kind of running on unstretched medium-primed canvas sheets, which suits her style perfectly.

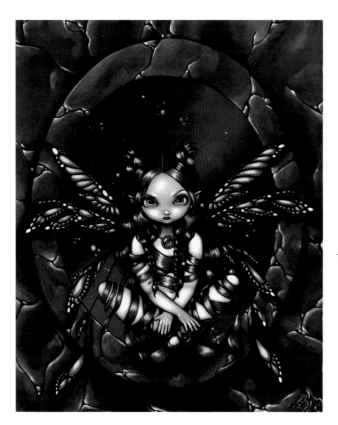

A variety of large soft brushes are first used to paint a layer of opaque darker colours. to set up the background scene in her paintings. She will usually incorporate many layers into the background – whether it be a solid black void, a starry night sky, or a lush verdant jungle. Then, with a medium or small brush, she carefully adds in the background

↜ *Starry Night Fairy*
*24 x 30 inches. Acrylic.*

This is one of my personal favourites, and also a good representation of my current style of work. These faeries with their large eyes have become one of my trademarks, and are caricatures of my own face – stylized self-portraits in a way. For this reason I have selected this painting to appear on the cover of my upcoming art book.

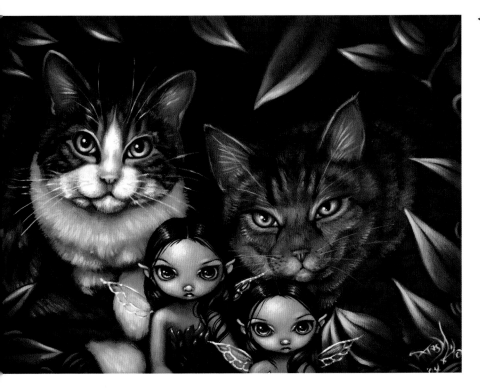

**↪ *Pixie Cats***
*16 x 12 inches. Acrylic.*

I have often wondered about the relationship between faeries and animals, both domesticated and in the wild. Cats in particular are often much more receptive to the supernatural, and also show a great interest in animals smaller than themselves, so it would make sense that they could spy faeries more readily than any self-absorbed human! The cats in this painting belong to my friend (and fellow artist) Carrie Hawks. This started off as a portrait of her two kitties, and of course, being a painter of faeries, a couple of little pixies somehow popped into the painting. Her cats must be very well-behaved – mine would have been batting at the pixies by now!

details – plant life, trees, stars and swamps. It is this attention to detail that gives depth to the final image.

All of her fairy girls begin looking naked and bald. Sketching the outline with a scriptliner brush helps her to visualize the final layout, proportion and pose. Building up further with dark neutral colours to lighter midtones, creates the glazed layer, building a three-dimensional look to the image. Bold with her use of contrasts, Jasmine never hesitates to use pure white for the final highlights or pure black to achieve that 'otherworld' look, with her figures incandescent against the background. Are her figures self-portraits? Well, lets say she does not deny looking in a mirror for the big eye paintings that have become her trademark.

Jasmine lives in Florida where she has her studio. Matty her husband, a framer by trade, looks after the growing distribution business. Just a small walk away she is surrounded by lush jungle and amazing swamps, providing so much inspiration that it is no wonder the magic of Faery happens here.

**To Love a Frog** ↪
*12 x 16 inches. Acrylic.*

Even among faeries there are eccentric outcasts who prefer the company of animals to those of their own kind. This gloomy young fairy has forsaken her faery court to instead dwell in the swamps with the frogs. In this portrait of her she is jealously clutching one of her best froggy friends. Living in Florida, I am surrounded with swamps and of course frogs, which is no doubt the inspiration for this piece! I've often thought that frogs have a somewhat magical quality to them, so it is not surprising that they would associate with the faery folk.

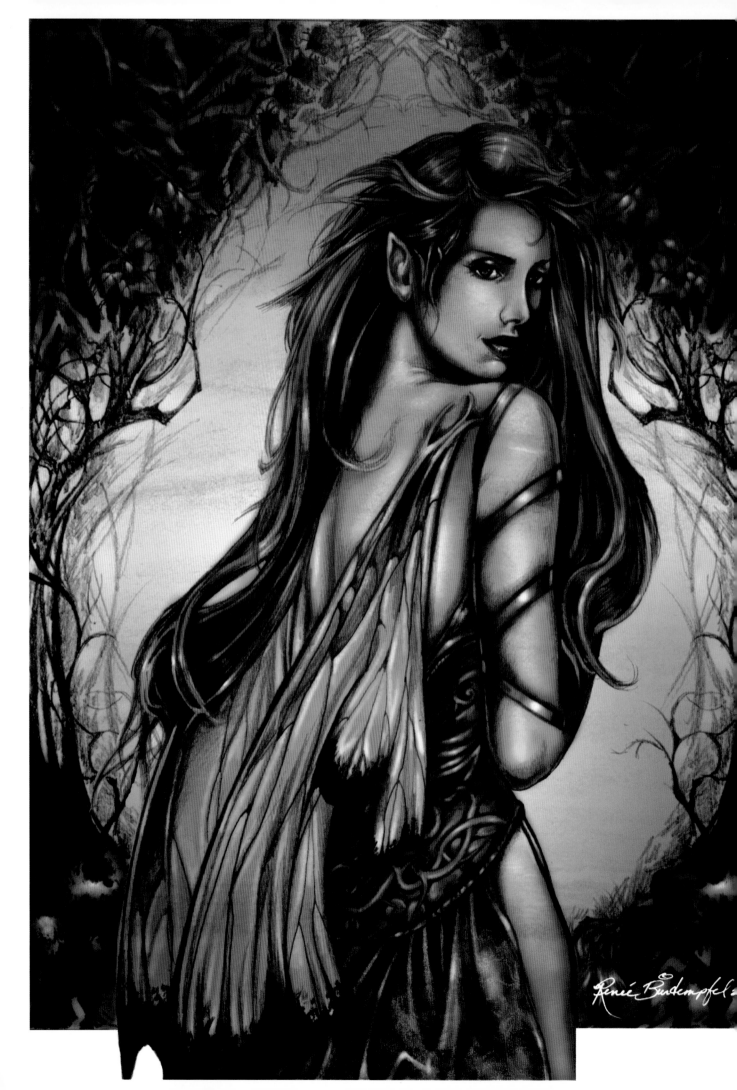

# RENEE BIERTEMPFEL

RENEE BIERTEMPFEL currently resides in Pittsburgh, USA and grew up in the beautiful countryside of Harmony. Learning to paint was a built-in process as her biological mother and father were both artists. Her adoptive family were extremely supportive of her artwork and provided her with lessons at a very young age, all the way through to college. There were, and still are, many influences on her artwork, from music and role-playing to fantasy movies and nature. Art Nouveau and Pre-Raphaelite art has always been an inspiration. Renee also finds Brian Froud and Alan Lee's art incredibly captivating, but nature is probably the greatest influence. Growing up in such beautiful countryside, filled with deep woods, large old mossy glacier stones and running creeks and brooks, was a very magical experience. She would either sit on one of the old rocks in the woods and daydream of fantastic places and beautiful beings or, at night, visit one of the grassy fields nearby and whilst gazing at the moon and stars, she would get her ideas and creative inspiration.

### ᔆ Wood Faery
*11 x 17 inches. Graphite pencil and Adobe Photoshop.*

Wood Faery is a graphite sketch digitally painted in Photoshop. This piece was done right before a painting breakthrough and has that kind of emerging took, like a spirit coming out of the dark wood into the light of day.

### ⚶ Celestial Faery
*11 x 17 inches. Graphite pencil and Adobe Photoshop.*

Celestial Faery is a graphite drawing painted in Photoshop. This is my favourite piece because it developed the way I hoped it would and I feel she really wanted to come out on paper. I love painting night scenes, they are my favourite type of painting to do.

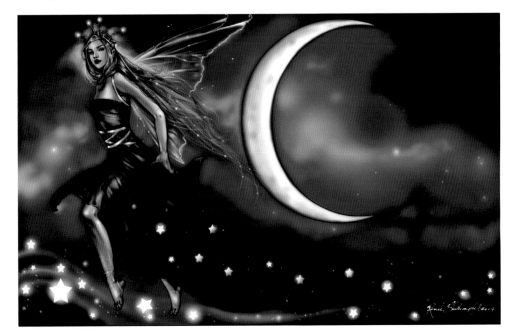

Her formal training came from her many classes when she was younger and she earned a visual communications degree from the Art Institute of Pittsburgh in 1992. Although very skilled in traditional oil painting she loves working with prisma colour pencils. However, the medium Renee prefers to work in is digital, with Photoshop and Corel Painter, which she uses to colour her graphite sketches. She has really studied to perfect her digital skills and is continually striving to improve, but without her other drawing and artistic skills it would be impossible to achieve such spectacular results.

Renee always strives to make her artwork vivid, colourful and striking. She feels the most important part of attaining a realistic quality to her subjects is achieved by studying classical underpainting techniques – a technique she only started studying five years ago. When starting a drawing she roughs out a preliminary sketch to get a feel for where the image is going, then tightens up the image until she has a final drawing to be scanned and digitally colourized. How long a image takes to complete varies on the complexity of the image details and the scene she is creating. It could be a few hours or even days before an image is complete.

She has always been strongly inspired by fairies and magical beings. "They almost come natural to draw without effort. To me I think they represent freedom – creative freedom." She likes creating and designing their looks from flowing detailed costumes, exotic jewellery or long glimmering hair. She hopes to convey messages through her art, imagining that viewers may, for just a short moment, escape and forget their troubles and get lost in her images. Renee would like to even inspire the viewer to tap

### ⚘ Spring's Muse
*11 x 17 inches. Graphite pencil and Adobe Photoshop.*

*Spring's Muse* is a graphite sketch digitally painted in Photoshop. I think of the elven being in this piece as spring's inspiration. She plays music to inspire the birds to sing.

### Gypsy Faery
*11 x 17 inches. Graphite pencil and Adobe Photoshop.*

*Gypsy Faery* is a graphite drawing digitally painted in Photoshop. I really wanted the colours to be striking in contrast and her look to be very gypsy-like.

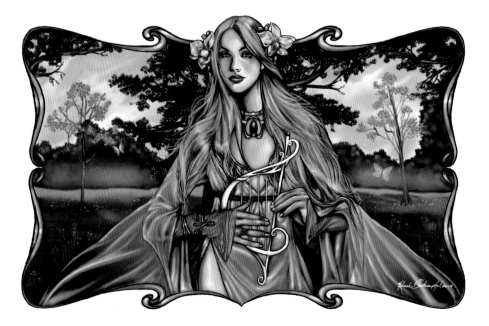

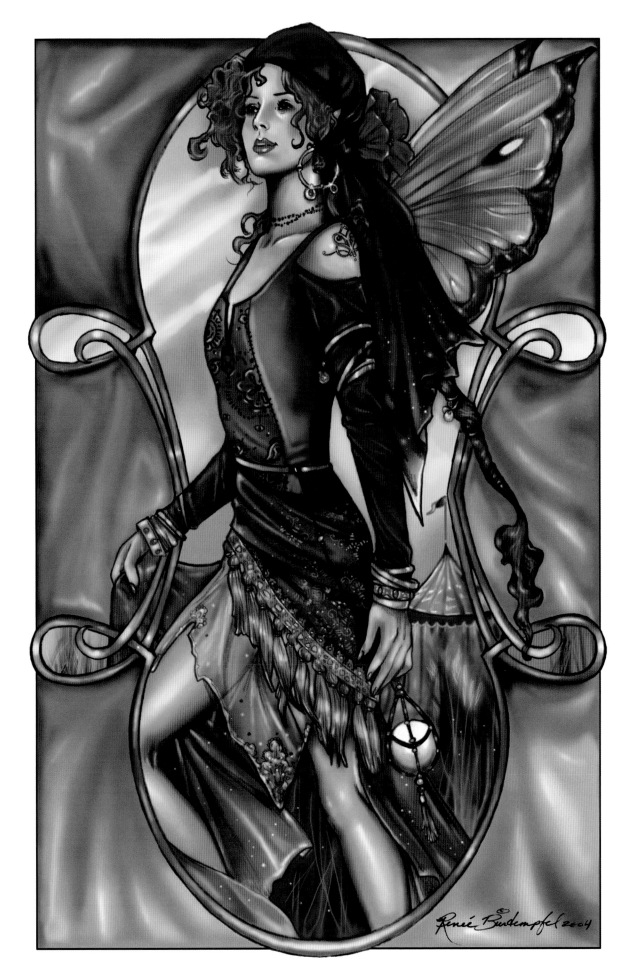

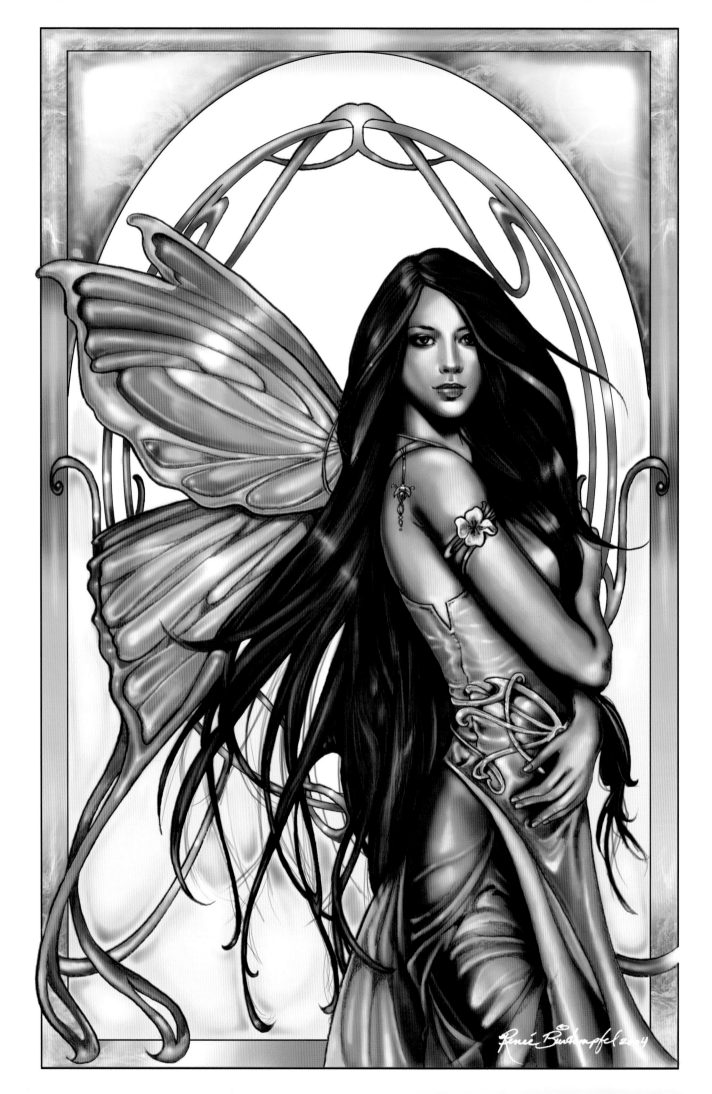

into their own creativity, "I know that is what beautiful artwork does for me, giving me something to drift into and make me think and dream."

Renee is in partnership with *Land Of Myth and Not* whose primary focus is Faery and Fantasy art, so she illustrates a lot for them, whilst they market her images. This allows her much input and also the freedom to come up with her paintings. She is also a book illustrator for a publishing company in Pittsburgh.

As for her artistic future, "More paintings!" is the promise from Renee. Constantly working hard to develop her own profile and career, she feels her work has grown in leaps and bounds and is still evolving. "I cannot learn enough. I am always searching and trying to understand different ways of seeing and interpreting the world." Renee wants to inspire others through her art and to encourage people to stick to their creative path. She knows it can be long and rocky, but it's worth the journey!

*"She likes creating and designing their looks from flowing detailed costumes, exotic jewellery or long glimmering hair."*

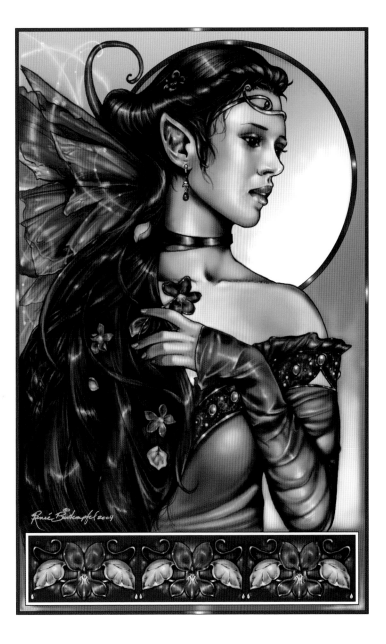

↢ **Bryony**
*11 x 17 inches. Graphite pencil and Adobe Photoshop.*

Bryony is a graphite drawing digitally painted in Photoshop. Once again an Art Nouveau inspired piece. I really focused on the costume and jewellery on this one. I was trying to achieve a stain glass effect in the border which came out well.

**Violet** ↤
*11 x 17 inches. Graphite pencil and Adobe Photoshop.*

Violet is a graphite sketch digitally painted in Photoshop. I really focused on the hair on this piece as I wanted to give a lustre effect to her long locks.

# LINDA BIGGS

EVENTS FOR LINDA BIGGS have been moving in ways that she could never imagine. At the start of the millennium she finally started to show her artwork after years of requests and encouragement to do so. Since then, with her head full of ideas, fighting as she says to get out and onto paper, she is now seeing the benefits; grateful that her fairies in some magical way have helped to heal some very deep wounds in others and even herself. Knowing this gives her help to focus and the desire to paint every day art with fresh meanings, where even small images will have their own little stories.

A trend has begun to develop with her clients, who in many cases are often purchasing a piece in remembrance of someone. She herself doesn't quite understand, but each time she hears their heartwarming stories, "I get goose bumps." She first took real notice when a gentleman commissioned her to paint his late daughter. He wanted her painted as a beautiful fae and wished to present it to his wife, her mother, as a healing gift. That first painting was the most challenging, but Linda is now asked to portray many dearly departed loved ones and has a deep empathy and connection with her clients, intent on building memories that live on.

She shows her fae at the Spoutwood Farms Fairie Festival in Glen Rock PA, a festival she has been attending since its beginnings. "To be one of the artists there is the most decadent fairie fun you can have." She also shares her work at the Sugarloaf Crafts Festivals – out of Gaithersburg MD, where the Festival goers seem to really enjoy her work. Linda goes dressed in full fairy costume, from the sterling silver tiaras she creates to fairie gowns and wings of all kinds. Her collectors really enjoy that part of the fantasy.

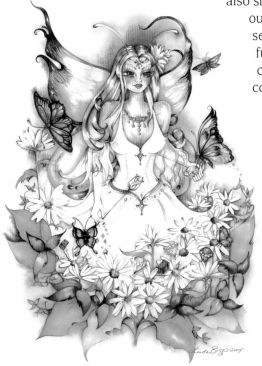

*"The most important element of any of her paintings is the eyes of the fairies or mermaids. 'They must be alive with emotion, if not I start over with a new image!'"*

### ✦ Diamond and Daisies
*19 x 25 inches. Watercolour.*

This fairie is all about happiness. She is also representing some of my favourite things – I love diamonds and daisies are my favourite flower.

Linda recognizes that her artistic technique is still maturing, She likes the progression and is now painting much larger originals – approximately 22 x 26 inches. Her colours are much brighter and deeper and more vibrant, including as much nature as she can: butterflies, dragonflies and flora. The most important element of any of her paintings is the eyes of the fairies or mermaids. "They must be alive with emotion, if not I start over with a new image!" Collectors are constantly telling Linda that her art has healing qualities – her paintings cannot fail to make you smile.

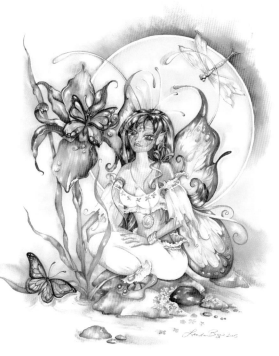

### Native Spirit
*19 x 23 inches. Watercolour.*

This was painted to represent my Grandmother. She was such a wonderful inspiration to me, a Cherokee woman with many challenges, who worked, lived and loved life until the day she passed away. She was 93 I think, and lived as if she was in her 30's. We shared many special moments together and she knew all my little secrets.

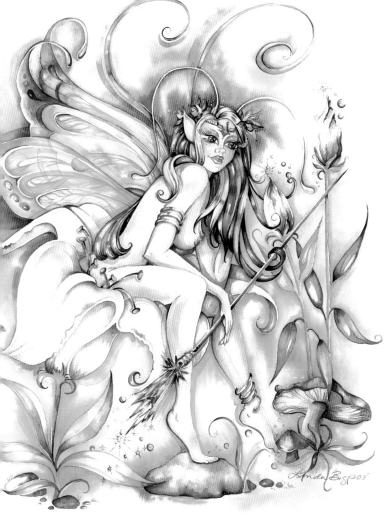

### Jezebell
*17 x 21 inches. Watercolour.*

She is basically what 'Jezebell' in the bible represents; a wicked and yet beautiful creature, and not modest at all!

# AMY BROWN

AMY HAS HAD SOME exciting changes in her life. The biggest and best change was the birth of her daughter, Isabella, who arrived just months before *The Art of Faery* was released in 2003. Then there was the debut of her new website, designed to become a destination site for faery lovers everywhere to be able to view a diverse collection of faery images, as well as purchase art from various artists through a single site. It has been a source of great fun, but it is time-consuming as well. Another exciting development has been the release of Amy's first solo book.

Most of Amy's paintings begin with an idea, sometimes just the tiniest spark of an idea. It can be triggered by a word she hears in passing, a book she might be reading, a song, movie, or the work of another artist. Sometimes a painting begins with nothing more than an interesting pose. "I like to keep a journal of all of my ideas. Then, when I'm stuck without inspiration, I can flip through the book and hopefully find inspiration."

Amy rarely does preliminary sketches. Usually she starts drawing directly on watercolour paper, lightly so she can erase and re-draw when necessary. If a drawing refuses to evolve properly, she will set it aside and start on another. Some drawings can take ages to complete, only sometimes will she outline the image in ink before beginning to add watercolour washes.

Amy starts to paint once she is happy with the drawing, always doing the background first, whether it consists of light washes of colour or multiple layers of pain, next focusing her attention on any inanimate objects in the background: trees, rocks, walls and water. She uses salt, wax, ink or coloured pencil to create different textures. Once the entire background is finished she works on any secondary figures, which might be goblins, pixies, or animals. She prefers to paint the central figure last, concentrating on skin tones first, following on with clothing, wings and hair. Each aspect of a painting involves a gradual build up of colour. Background washes can have as many as five or six layers of paint, clothing usually has at least two layers, while four or five layers are needed for hair. White gouache or coloured pencil is used for accents and highlights.

As with most artists, Amy finds painting skin tones most challenging. Her usual technique for skin tones starts with shading in Dark Umber,

## ♀ Rose Red
*11 x 14 inches. Ink and watercolour.*

*Rose Red* was painted during a period of time I experienced recently where I was a little obsessed with roses. I did several paintings with roses fitting into the theme somehow. This is absolutely normal for me; I get stuck on one idea and have to work it out over and over in different ways, different paintings. I sometimes revisit themes repeatedly over several years. Every painting has so many directions it can take before it's completed, that I sometimes feel the need to explore as many as possible before putting that idea to rest.

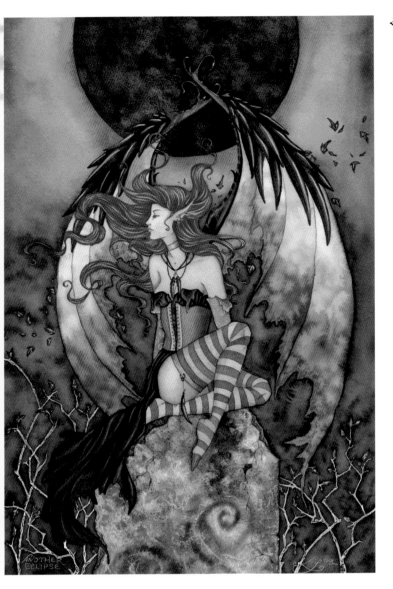

↩ **Another Eclipse**
*11 x 20 inches. Watercolour.*

In *Another Eclipse* I wanted to play with bright, conflicting colours. Using colours that fight with each other makes the image stand out. The colour scheme draws the viewer's attention to the piece.

*"To me a simple image makes a bigger statement. The viewer can look at the painting and get an instant, raw emotional reaction."*

followed by purple, blue or red accents, depending on the mood and colour scheme of the piece. Next, she adds a layer of Burnt Umber and tops it off with a very watered down layer of Buff Titanium. For pale, vampire-like skin, she focuses on blues and purples in very light washes. Darker skin tones are the most difficult, as they need a warm underglow to look realistic. Amy tackles this by highlighting several areas in red tones before adding washes of warm brown. If it's done correctly, the red undertone will give a lively, flushed effect.

Amy likes to work small, most of her paintings are no bigger than 11 x 17 inches. As she easily gets bored with an image, she trys not to spend more than three days on any piece, whether it's 8 x 10 inches or the rare 22 x 30 inches. Normally, she spends roughly six to ten hours on a small painting. However, that does not include the drawing time – some drawings can take Amy days, months, or even years before she is happy enough with them to start adding colour. She prefers to paint simple pieces, with one strong, single character. "To me a simple image makes a bigger statement. The viewer can look at the painting and get an instant, raw emotional reaction." She hope you will enjoy viewing her striking paintings here.

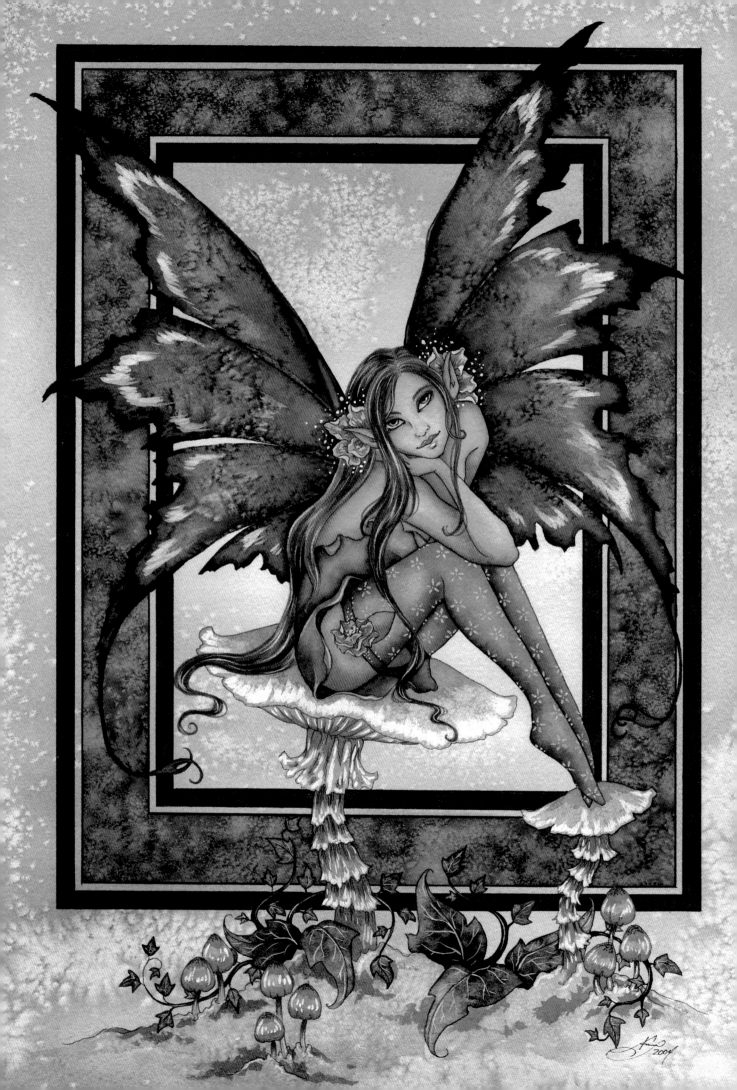

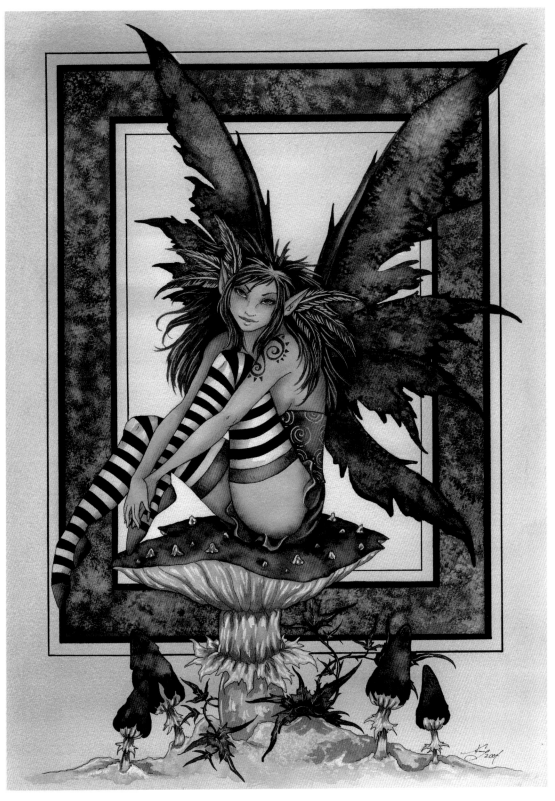

### ꙅ ♀ *Nice Faery* and *Naughty Faery*

*11 x 17 inches. Ink and watercolour.*

*Nice Faery* and *Naughty Faery* were created simultaneously. I tried to tie them together with a similar overall design and used shades of purple in each piece. The Naughty Faery is painted in wild rusts and dusky purples, while the Nice Faery is painted in comforting blue and bright purple hues. The backgrounds on both pieces are reminiscent of French matting techniques. I was a picture framer for more than seven years and I find that framing influences creep into my paintings now and then.

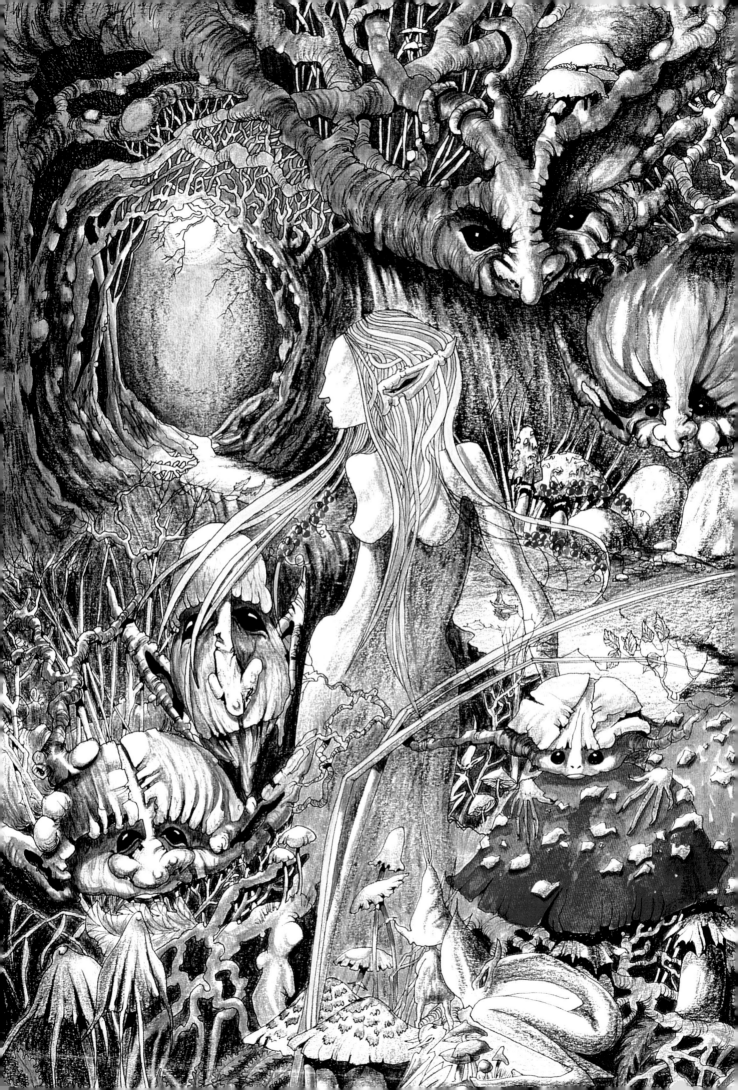

# HAZEL BROWN

A WALK IN A WOOD, whatever the season, will always bring that "particular awareness" of Faerie into Hazel Brown's senses, plus, that elemental vitality and "numinous" of place, a vibrant, prickly energy that tells her there are faeries around.

Now that she lives close to the moor, Dartmoor in Devon, the past is all around Hazel, in wild uplands, open moorland ablaze with yellow gorse and purple heather, and the rocky out-crops of ancient Tors. The Bronze Age village of Grimspound is just three miles "up the road", eerie and deserted in the mist of a November afternoon. The Forest of Fernworthy, Wistman's Wood, Trendlebere Down – all gateways to the enchanted world of faerie – only open their gates to the believer, connecting us not only to the spirit of the Greenman, but to the hoards of faeries, elves, boggarts and brownies, spriggans and sprites that still inhabit these wild places.

Although Hazel continues to maintain a strong belief and connection with faeries, there is also the struggle with clumsy mediums, such as paint and inks. To represent faeries with honesty, in their true and vibrant forms, Hazel finds they crowd the page, they lose her pencils, smudge a drawing, bend her best pen nibs and leave muddy footprints all across the paper. And yet, after much bickering, pinching and poking each other they primp and pose to be first on the page.

Just recently, a friend of Hazel's grandson, when seeing her faerie paintings for the first time, casually said, "Oh, we have a photograph of

**Wood Faerie**
*16 x 12 inches. Coloured pencils and watercolour.*

She appeared to me one evening at twilight while I was taking a stroll through some nearby woods. I was suddenly overtaken with a great sense of loss, aware of her strong presence on my inner vision. She seemed to be rooted to the ground, her skin like birch-bark but luminous, and with a musty smell like rank vegetation. She had the aura of a guardian with a message – "Respect our woodlands!"

**Wood Elves**
*16 x 12 inches. Watercolour and ink.*

I saw these beings as bright, instant moments of pure light, ever changing and pulsating faeries, whilst the old Woodelves ruminated and stared back at me from the roots of the trees.

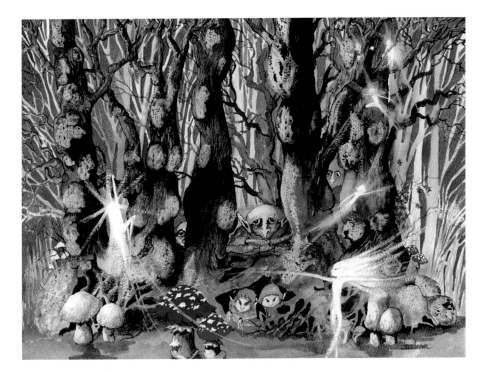

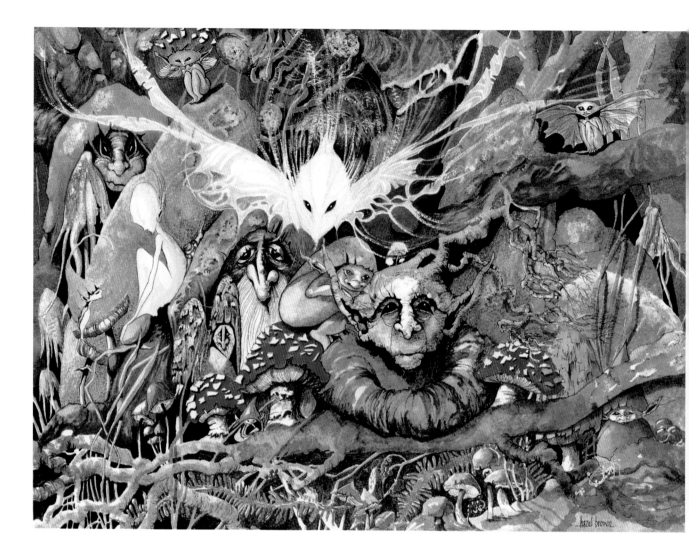

hazel brown

### Oak Men
*16 x 12 inches. Watercolour.*

I love to visit the ancient oak woods on Dartmoor. Whilst sitting among their twisted roots and moss covered branches, I become aware of the timeless old Oak men who provide the energy for regeneration in their dark underground world – a world of rotting vegetation, leaf mould and fungi, an endless process of decay and transformation. Meanwhile, the more transient beings emerge from this undergrowth, expand their wings and fly up into the light, bringing warmth and colour to the flowers and new leaves.

### The Faerie Child
*8 x 12 inches. Pen and ink.*

Appearing in moonlight, luminous and transient, this faerie child, close to her mother, radiated pulses of warm healing light, drawing me towards the oneness of Nature.

*"...the past is all around Hazel, in wild uplands, open moorland ablaze with yellow gorse and purple heather..."*

some faeries we took a couple of years ago when we were all out for a picnic in some woods. Honest, it's really true. We were all sitting around and right behind us you can see these faerie things – I'll get the photo and show you."

When Hazel asked another friend, a commercial photographer, if he ever had any unusual snaps given to him to develop, he said, "Well, I had some prints the other day with faeries in them!"

Keep believing folks, they are out there and waiting to come into your lives.

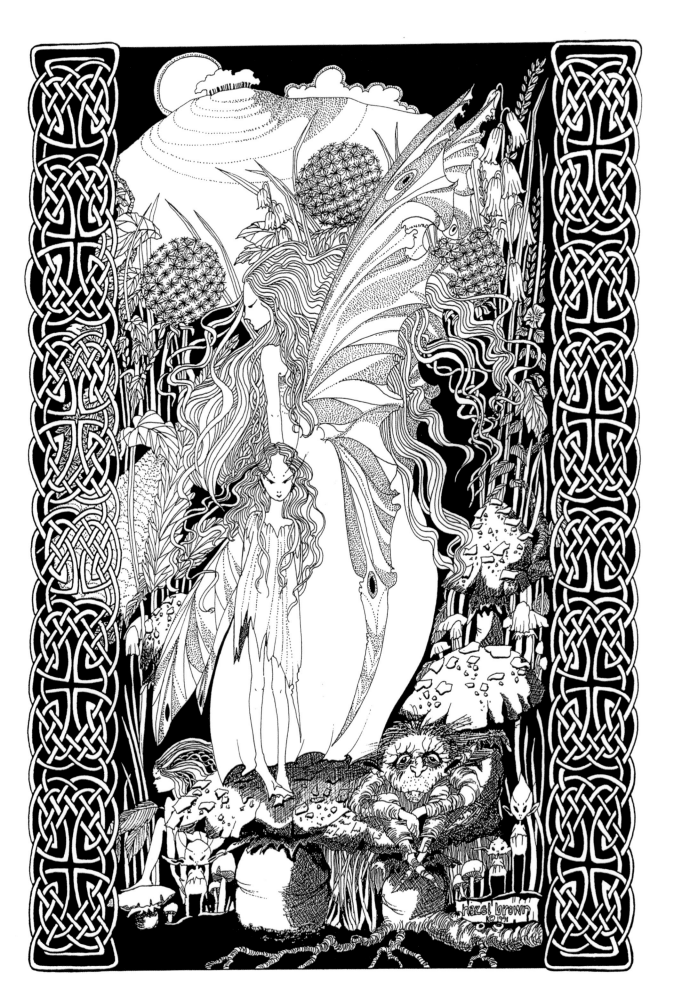

# JAMES BROWNE

OVER THE YEARS James has grown very fond of the subject matter that he paints. It is as real to him as life itself. In his studio he can see the elves and faeries cleaning his brushes and leaving faery footprints all over his palette.

He believes faeries are as real as all of us and that you only have to open your mind and use your imagination. "As an artist I have always prided myself on bringing things to life on paper and giving the viewer something that they can believe in. In a world of so much negativity and turmoil I am truly thankful that I can paint a more positive and dreamy world."

As James gets older and his artwork matures, the more his heart yearns to create. This yearning has become his passion, a passion where his true emotions flow out of him as he paints. He believes that when you create you have to open yourself up and reach deep within to really get a feel for what you're all about and what you hope to say or express in your painting. Then everything you paint becomes real to you, and for the viewer anything is possible. He paints for that very reason.

### The Dew Faery
*5½ x 8½ inches. Watercolour.*

I was inspired to create this piece after a long and dismal winter. She is a spring faery. I wanted her to convey the feeling of warmth and life. This painting was created purely on emotion and the welcoming of spring.

### The Monarch
*12 x 18 inches. Watercolour.*

I was commissioned to create this painting of two beautiful sisters who were in love with the fae. I truly feel that this is one of my more joyful paintings. These girls were absolutely lovely models and they were so excited to see themselves as faeries.

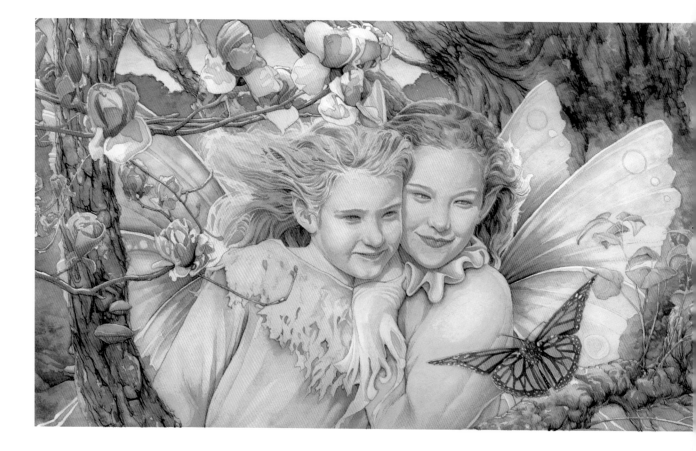

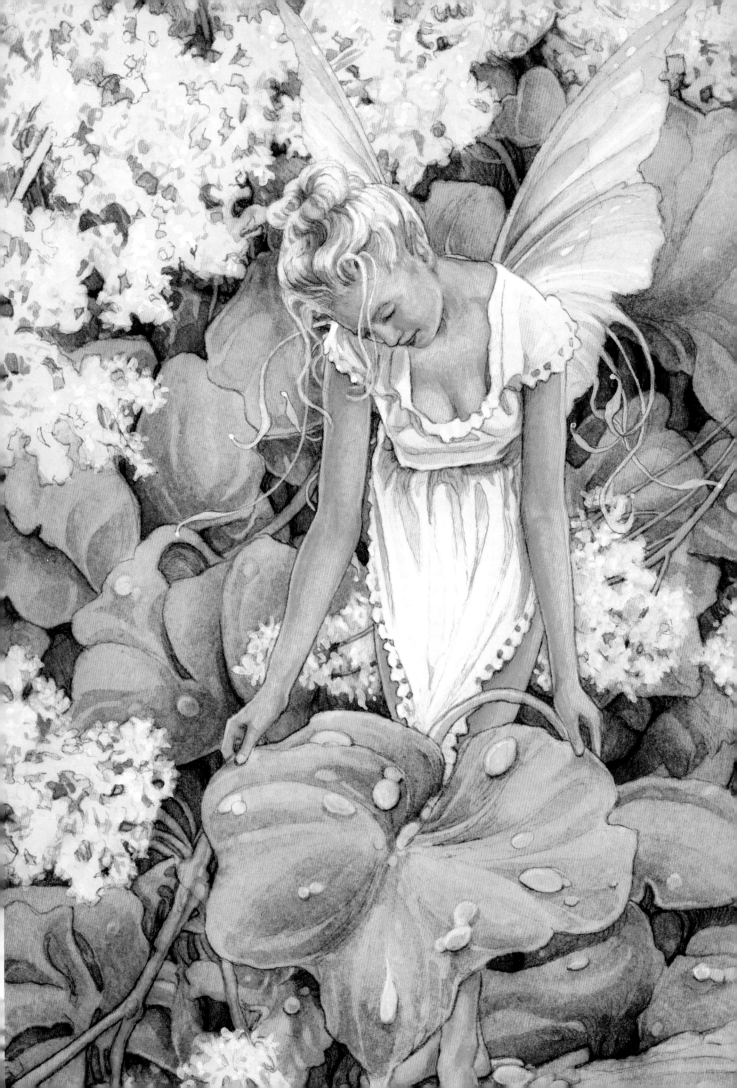

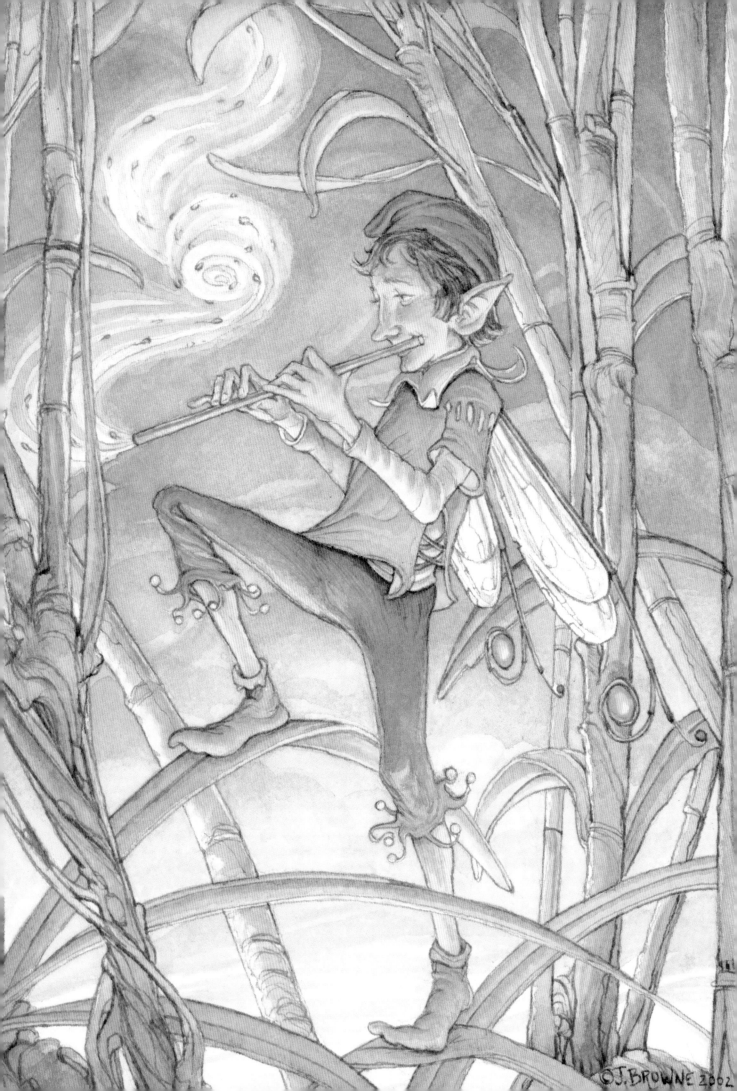

"It is a wonderful feeling to share my imagination and emotions with people through my paintings."

In his spare time, James continues to paint inside his head. As he walks alongside a stream or through a wooded path, or even looks into the eyes of his beautiful wife, Nadine, his mind sees breathtaking imagery. There are so many things around him that he finds inspiring and he never takes that for granted, even if he has to stop, close his eyes and feel the moment.

Most importantly though, people are his biggest inspiration. From the gnomes behind his bookcase to his lovely muse, from the amazing artists before James, to the people he has taught over the years, from the elderly woman sitting on a park bench to the young boy with his shoes on the wrong feet. "People are truly what inspire me most, and that is who I paint for."

James' career continues to bring him blessings. The smiles, the comments and wonderful sighs of believing in a magical world are all food for his soul. At present there are many new opportunites for James, a figurine line is being produced and he has also been working on the illustrations for two trilogies.

He continues to create various commissions for people, with the most common theme being the individual in a magical setting. His faeries and elves continue to work stocking up inventory that he sells at festivals, shops, and through his website, www.JamesBrowne.net.

### Yaamas
*4½ x 5½ inches. Watercolour.*

Well, here he is, my personal assistant! Usually busy mixing paints, fetching water and cleaning brushes, little Yaamas enjoys some time alone thinking of a new idea for a future painting. He's also been known to add input to my paintings on occasion. I like to think of him as my "inner child."

### The Faery Piper
*5 x 8 inches. Watercolour.*

Being a musical faery, the faery piper's mesmerizing song can often put one to sleep. I have only come under his spell once, when I was lying in a field looking up into the clouds one afternoon. I heard his song and fell into deep sleep and was suddenly awakened by the cold night air. The song was too beautiful to put into words.

# JACQUELINE COLLEN-TARROLLY

**Aiyana**
*11 x 15 inches. Acrylic.*

This was a commissioned piece, and I am so grateful to the woman who asked me to paint it for her. It has become one of my favourites and a bestseller. The woman was going through a major changes in her life, growing, changing and maturing. She wanted a tattoo to reflect that in herself. She requested the butterfly element, but other than that I was on my own. I made the wings very large to show that the change was the overpowering force in her life right now. Her nakedness shows how vulnerable and innocent she was during this time. The peacock wings represent the feminine vanity and pride in our womanhood. The colours chosen are the green of the earth to show nurturing and growth and life, and the darker purples and slight greys to symbolize the grief and pain of change. Finally, the butterflies around her symbolize the support of her friends and family. The woman was very pleased with her image and it has helped her to rebuild her confidence and life and to speak helpfully to many other women. It's one of my better pieces. I believe it has a lot of soul.

I N 2002, Jacqueline Collen-Tarrolly had only just become a professional artist when our pixie scouts recognized her creative talent. Now she can reflect on that opportunity to show her work as an emerging artist and the result of her own efforts to develop her career further.

Her website www.toadstoolfarmart.com has grown beyond her wildest dreams. She receives many invitations to attend Festivals and Fayres across the United States, many impossible to do as her time is so limited. The festivals take her away from home where there is so much to do. Her other love is breeding horses and someone has to be there to care for them. However, she does always attend the Southern California Renaissance Fayre for seven weekends in the Spring, and the Northern California Renaissance Fayre for six weekends in the Autumn.

In summer 2004 she worked at Brian Froud's Annual Faerieworlds Festival, Portland, Oregon. "Camping there in that magical location is an amazing experience. It is far outside the nearest tiny town and you drive down the windy dirt road bordered on both sides by ancient woods, dripping in moss with sunlight filtering through the branches to dance on wildflowers and grasses." There are many artists and vendors at the festival who normally only communicate on the internet, so at last Jacqueline had the opportunities to meet them. It is the finest venue for faery art and friendship, a magical weekend no faery lover should miss.

Jacqueline's personal artistic style has beome more consistent now, helping her to make her mark. She now

**Arachne**
*11 x 15 inches. Acrylic.*

According to myth, Arachne was a Greek maiden who dared to claim that she was as good as the goddesses at weaving. They challenged her and she was indeed as good as they were. For her insolence she was put to death, but later on, out of pity, they turned her into a spider and that is where we get our terms Arachnid, Arachnaphobia. So that is the legend, but why did I paint her? I am fortunate to have a stable of horses. Horses attract flies, many many flies. Spiders eat flies, spiders are my friends!

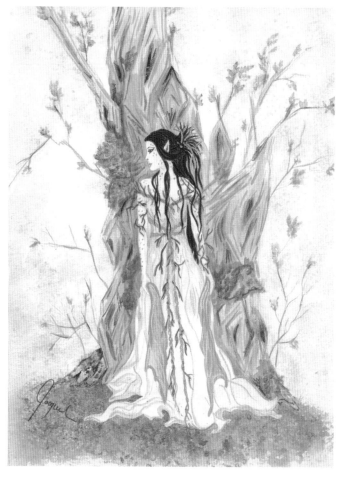

I'd been watching *The Lord of the Rings* films when I decided I needed to do some pieces without wings, of elves rather than fairies. This one was meant to have the same tall grace as the trees themselves. She is a spirit of the woods, a guardian of trees. I wanted her tall and straight and proud and benign.

feels that her work is becoming distinctly her own. She continues to work using a mixed medium to produce her characteristic images.

2004 saw her family moving as well. She left behind her beloved old house, a magical cottage built on a fairy mound in part of the San Femando valley, which she still thinks of as home. However, she needed space for her horses and had to find a place where they could be with her instead of all being boarded. So, along with her husband and horses she packed up and moved to another cottage in another part of the Valley. It was a historical home in the Hollywood sense, because it once belonged to Ava Gardner and Artie Shaw and over the years it had fallen into a state of disrepair. Bringing it back to life has been an adventure, at times discouraging, exhilarating, frustrating, and fun, yet always a labour of love.

Thank goodness the Fae of her old home, 'Toadstool Farm' have happily followed her, their little faces and energies running about bringing new life to her garden, and a new spirit within the wall of her home and studio. Why not pay them a visit at www.toadstoolfarmart.com. You will always be welcome.

*"Thank goodness the Fae of her old home, 'Toadstool Farm' have happily followed her, their little faces and energies running about bringing new life to her garden."*

**The Queen Mother** ↬
*11 x 15 inches. Acrylic and watercolour pens and micron archival pen.*

The same man who commissioned the *Queen of the Fae* liked his piece so much he immediately commissioned me to do a second one, this time for his wife. He wanted a Queen holding a baby. This is the result. He is very happy with it and so am I thankfully.

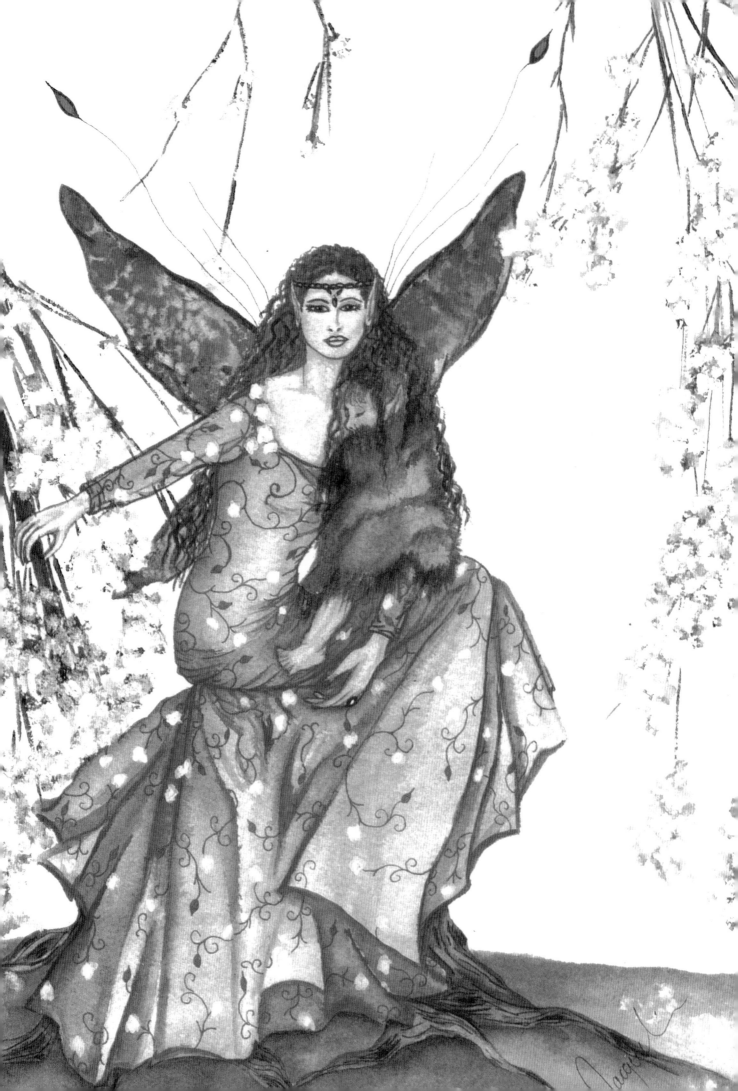

# JESSICA GALBRETH

**Moon Petal**
*11 x 17 inches. Airbrush and acrylic.*

With iridescent wings as delicate as flower petals, she rests serenely as the light from the full moon above bathes her gossamer skin. Her head is bowed in introspection as she dreams of a new world where all will believe in the magic of fairies.

JESSICA HAS ALWAYS FELT that we, as individuals, see the world of faery according to our own state of mind. Because our current situations are ever-changing, and our emotions evolve depending upon our circumstances, it is only natural that our visions of faeries can also change and evolve. She experienced this herself in fact, and it has translated directly into her faery art.

Her own style of painting faeries emerged with bold, colourful and hard-lined watercolours. She became known for this style, especially for her darker faeries. However, due to a change in her life, Jessica was taken on a journey to see the world of the fae in a different fashion.

After much experimenting, she came up with a new painting process using a strange combination of airbrushing, pencil and acrylic. This method of painting involves airbrushing the background in various tones of the same hue. After that, the fairy is sketched onto the background using both black and white charcoal pencils. Then, coloured pencils are used to add a few touches of colour. Finally, a fine tipped brush and white acrylic paint are used for all the bright highlights.

Jessica found that she preferred deep blues colours, purples and blacks for background, and white for foreground – her new series began to emerge. The paintings were so different from Jessica's usual bold watercolours, she felt that they needed a new home on the web, so as opposed to adding them to her main website, she had a new gallery created to match the new style of art. The last of this series was actually finished just one week before her daughter, Julia Rose, was born. She truly felt that her new little one had been the inspiration behind the series, so it was dedicated to her. Not surprisingly, about a week after Julia Rose was brought home from the hospital, Jessica noticed a ring of toadstools in their front garden. In Northwest, Ohio, toadstools are very rare, so Jessica took this as a sign that the faeries had stopped by for a visit to welcome Julia to the world, and that they approved of her new series of faery art.

She has since gone back to painting her bolder, watercolour faery paintings. However, Jessica's Fairy Visions series continues to be very popular and she occasionally adds new artwork to it whenever she feels inspired. The following are several of Jessica's personal favourites from this series.

## Night Fairy
*11 x 17 inches. Airbrush and acrylic.*

With long locks blowing gently in the night winds, wearing a gown spun from silvery moonbeam threads, a night fairy rests beneath the light of a distant crescent moon. When daylight comes, she will vanish, only to return again at sunset.

## Dryad
*11 x 17 inches. Airbrush and acrylic.*

Beneath an eclipsing moon, a beautiful dryad sits...flashing a gaze filled with fairy magic and mischief. She is a delicate tree spirit known to inhabit the mighty oaks of the forest. If you listen closely, you'll hear her bewitching voice whispering her lonely song on the wind.

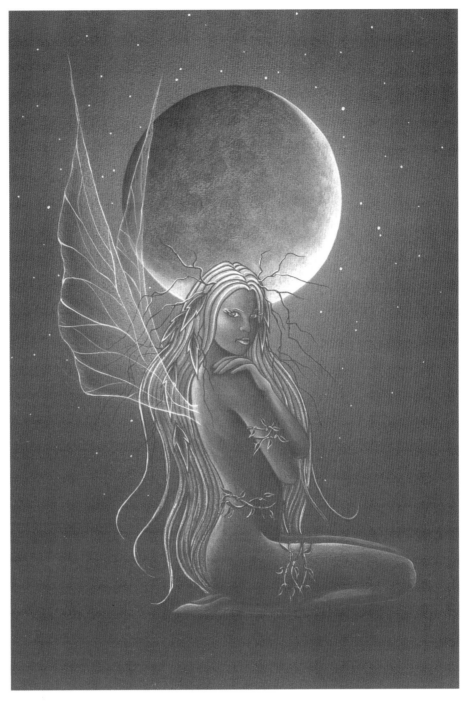

*"Jessica has always felt that we, as individuals, see the world of faery according to our own state of mind."*

Scott Grimando ©

# SCOTT GRIMANDO

GROWING UP ON Long Island may not seem like the ideal place to nurture a young fantasy artist, but you can find wonder wherever you are if you look for it. Indeed, the obvious contrast between the suburbs of New York and the natural world inspired Scott Grimando's interest in the hidden wonders of his parent's garden.

His father was a commercial artist so there were plenty of art supplies and encouragement from both his parents, and formal training began when he was 14. Scott was lucky to be taught by the most gifted of teachers at The Stevenson Academy of the Human Figure – Harold Stevenson, one of the few protégés of Norman Rockwell. Harold believed that art demanded technical skill to balance creative talent. As a teenager Scott was influenced by the likes of Charles Vess, Frank Frazetta, Brian Froud and Alan Lee. The more experienced he becomes as a painter the more he appreciates the classic Victorian school of art. The secrets of Bouguereau and Sir Lawrence Alma Tadema are slowly being revealed to him through intensive study and countless hours in the studio.

During a visit to the Metropolitan Museum of Art while studying a Maxfield Parrish painting entitled, *The Errant Pan*, it occurred to Scott that he was looking at a classical example of fantasy art. Parrish was depicting a myth; not of his own time but from ages past. In fact much of classical art reflects the archetype figures of mythology and symbolism of mankind's subconscious. The hero's journey and mystic's wisdom are just some of the themes that express universal human ideas in art history, much as fantasy and science fiction art does today.

Scott believes the modern visionary should study the depth of man's history and sees the promise of his future and the modern fantasy artist as carrying on a grand tradition. For Scott, "Fairies open up a world of possibilities for dramatic lighting. Whether they are lit by an inner glow or caught in a halo that illuminates their surroundings, the results are always dynamic."

After he decides on a composition and lighting effect, Scott has a model pose for it in his studio, carefully matching the angle and light direction in his background elements. He'll even photograph butterflies, birds and cicadas, alive or dead. This may seem a little morbid but the art students of the past actually dissected cadavers to study anatomy. His next step is anything but traditional. He'll bring all the elements into the computer and composite them into a montage. The computer is an unparalleled design tool. He can change proportions, work with colour schemes and paint directly over the image on screen to add details he might not be able to photograph. Once Scott is happy with the composition he'll transfer the drawing to a prepared piece of Masonite. From there on he returns to traditional painting techniques. A large painting can take Scott as long as a month.

**Chameleon Fairy**
*18 x 24 inches. Oil paint.*

I've always liked the idea that there are things all around us that we might miss if were not looking close enough. This was the first painting I did in my fairy series. After several years of doing book covers I decided I needed to go back to my roots and start painting in oils again.

The rose is used as a compliment to the green background and an anchor for the flesh tones.

*"Fairies open up a world of possibilities for dramatic lighting. Whether they are lit by an inner glow or caught in a halo that illuminates their surroundings, the results are always dynamic."*

When he first started this series of paintings a few years ago, he worked in vibrant floral colours. He quickly found that this was not his style. Scott wanted to diverge from the commercial work that he had been doing for a long time on fantasy and science-fiction book covers. Most of Scott's latest work is purely figurative, with sweeps of colour and light. He would like to work on a second Pan painting and possibly Oberon and Titania for a change of pace. If there's one thing Scott would like to portray through his paintings, it's a deep reverence for the natural world. "We may forget it sometimes but we are an integral part of the Earth's fragile balance. Maybe Fairies, in their roll as the shepherds of nature can serve as a reminder."

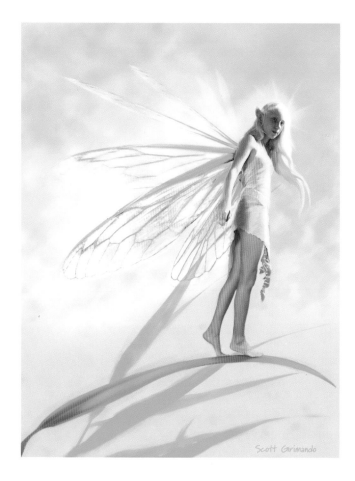

### Crushed Autumn
*30 x 40 inches. Oil paint.*

*Crushed Autumn* is my signature piece. Every once in a while an artist stumbles on something that strikes a chord with everyone that sees it. The painting welcomes deep inspection by playing with proportions and spiraling in on itself. Most people do a double take when they realize how small the figure actually is.

### On The Edge
*12 x 16 inches. Mixed media.*

This is meant to represent the fragile balance of Nature. Many people believe that the creatures of myth once roamed freely in the world and that man has displaced them so that they are now scarce and rarely seen. Most of my mixed media pieces are a combination of pigment inks, watercolour, pastel, and coloured pencil. They are often the colour rough or planning stages for the larger oil painting, as in this case.

### Swan Lake (pages 46–47)
*24 x 36 inches. Oil paint.*

The lake that I photographed for the background had swans in it, hence the name. I also thought that the relationship between the swoop of the tree and the grace of the figure was a little like a ballet.

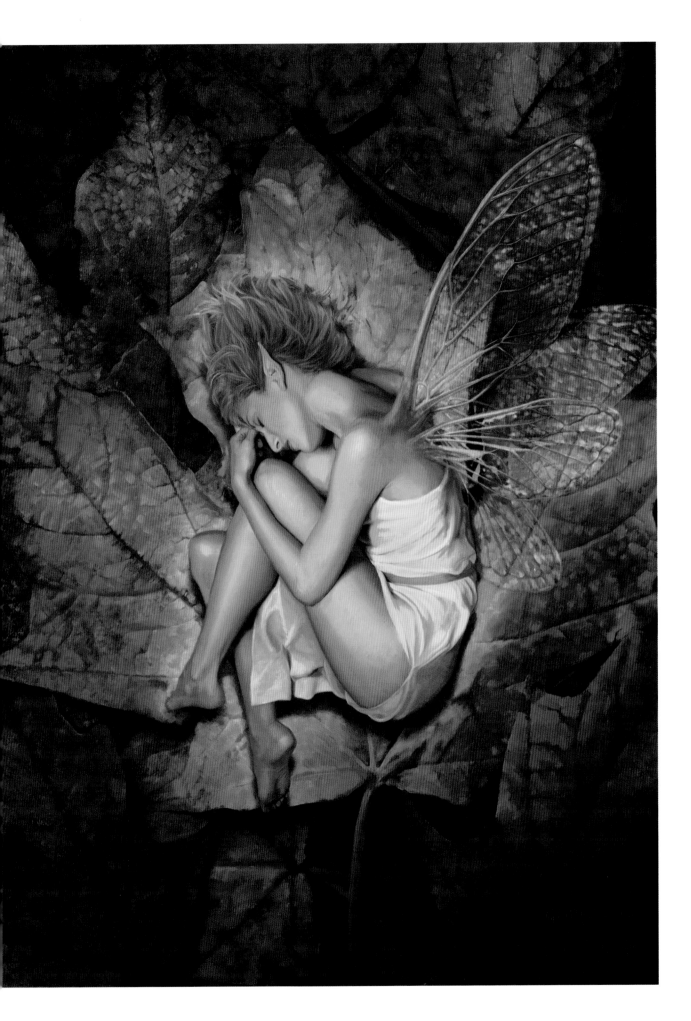

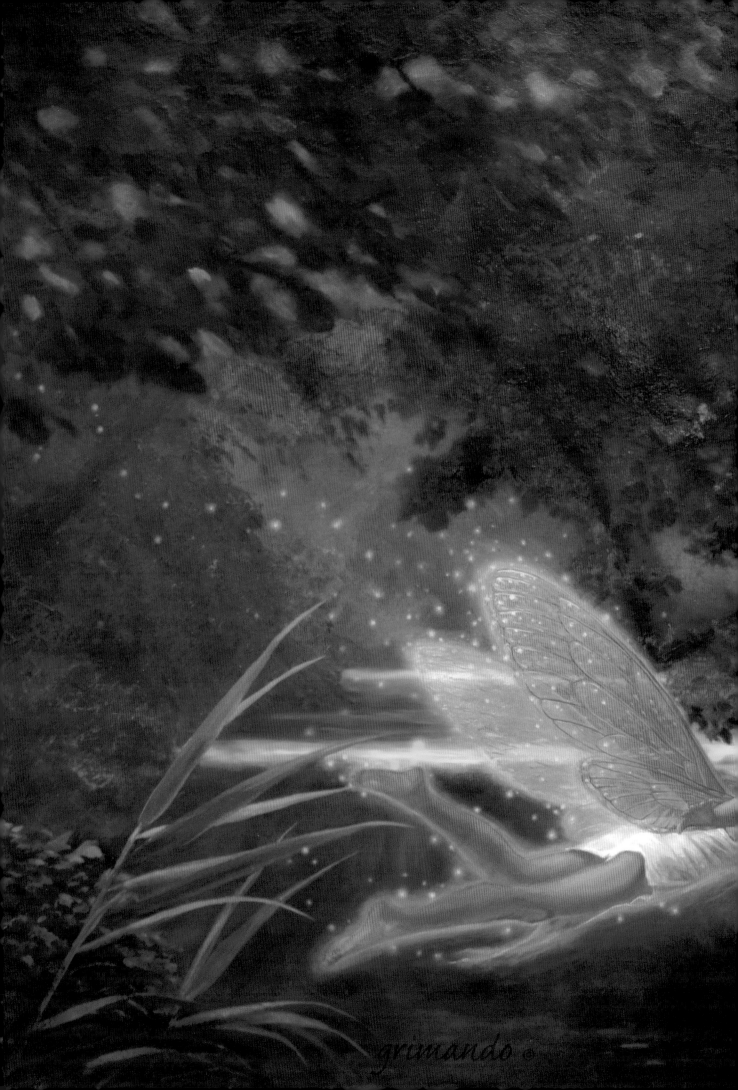

# VIRGINIA LEE

Throughout her teens Virginia Lee had a fascination for the surreal as well as the world of faery; the two seem to be integrated throughout her work; at college she designed a series of characters called the foodies, who had eaten too much of one kind of food and consequently, unsavoury transformations took place. When she embarked on her illustration degree at Kingston University, she spent the first two years exploring ideas and styles but not really finding her own particular voice. On that course, fantasy and faery art was frowned upon, but her interest in fairy tales and transformation seemed to be accepted and she developed more of an interest in fairy and folklore during this time, than she had done previously.

Virginia was particularly inspired by the animal and human transformations within these fairy tales, and what they symbolised. She was then able to explore these themes in her dissertation and grew to have a greater understanding of the archetypal symbolism that is universal in fairy storytelling.

Writers such as Angela Carter were of great inspiration, as well as the singer Bjork with her passionate and otherworldly music. She likes the work of surreal artist Remedies Varo, and the German artist Michael Sowa, who creates moody and atmospheric scenes. These influences helped her develop her use of colour, which she sometimes struggled with. Other influences are theatre and dance – the dramatic lighting used and expressive movement highlight emotional qualities that appeal to her.

Virginia's greatest inspiration is nature itself; its form and the way it interacts with everything. She sees parallels between its cyclical nature in the seasons and her own cycles and changes. All this encourages her to express herself in art form and to create a greater understanding for herself and hopefully others. To her the animal kingdom holds these parallels as well, and so she likes to reveal aspects of the

### ↵ The Capture
*7½ x 9 inches. Pencil.*

One of my many tree people drawings. I like exploring the relationships between trees and their inhabitants. This tree has noticed how beautiful the bird of paradise is and has decided to keep it to herself to admire all day long.

**e Tides of Emotion**
*x 19 inches. Pastel and pencil.*

d this idea for quite some time and initially tried to do it in colour
decided to try a new monochromatic approach instead. It seemed
ncomplicate the image and give more of a raw emotional quality,
natizing her being faced with the elements.

*Trees find themselves in her work*
*tinually, they are to her skeletons of*
*the soul, spiritual yet grounded."*

**Tree Girl Sculpture**   ꙮ
*10 inches tall. Plasticine.*

This tree sculpture was initially an experiment with
a new plasticine I had bought. I decided to do an
image of her because I knew she could not hold her
pose for long in her plasticine form. One day I will
make her in a more permanent material.

**The Deer's Domain**
*12½ x 13½ inches. Pastel and pencil.*

As I was walking through Fernworthy forest one day, the interior of the forest sparked the idea for this painting. I could imagine the deer maiden in her domain being woken by the gentle rays of light streaming through the windows of her forest as she rested under her mossy blanket.

**'Inner Seasons' (Blanket of Snow)**
*16½ x 10 inches. Pastel.*

This is one picture from the 'Inner Seasons' series that describe a girl entering puberty and seeing her own physical and emotional changes in the landscape around her. Now she has reached the stage where she has come to terms with those changes and finds peace as she lies down to sleep and lets nature look after her.

human psyche using the characteristics of animals. Trees find themselves in her work continually, they are to her skeletons of the soul, spiritual yet grounded. They are a tool to help her express the ideas and dreams of the fairy and fantasy world.

Her preferred medium is pastels, because she uses her hands to create quite atmospheric work, combining these with coloured pencil for finer detail and sometimes using paint to bring out highlights. Her approach is that of oil painting, building up the tone gradually then the detail later. She has tried other techniques in the past but they do not seem to satisfy her.

A drawing or painting would usually take Virginia two days to two weeks to complete, sometimes longer. Sculptures are a lot more time-consuming. Her main painting objective is to create a scene with an emotional message, by playing with lighting and atmosphere, drawing them into a landscape in which they can exist and be revealed. She hopes the messages she has illustrated in her art can convey the emotive and intimate passion she feels within the image.

Most of her two dimensional work and her sculpture has been self-initiated and sold as gallery pieces, with the exception of the two-and-a-half years working as a sculptor for the *Lord of the Rings* trilogy.

Her work has already been published in books, but Virginia has always especially loved children's books. Illustration of children's books and animation are two areas she will be looking to develop in her future career.

Virginia's paintings and drawings touch on the faery world and lead us to examine the powerful connection with our modern world through our connection with nature.

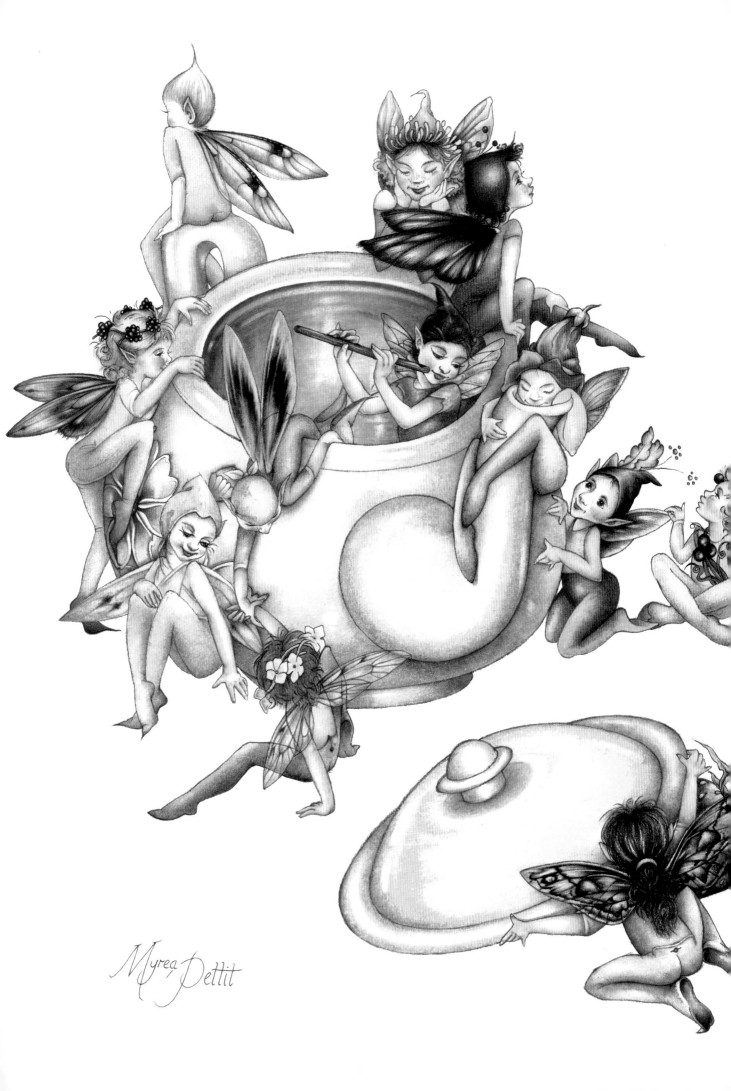

# MYREA PETTIT

M yrea Pettit has an incredible ability to radiate the magic and innocence of small children as fairies, her creative imagination capturing moments of pure delight, picture stories that one can spend hours over, just searching for the minutest, detailed expressions with touches of humour that charm with an enduring quality. Illustrations full of nostalgia fill the head with childhood memories of dearly departed family who read bedtime stories, awakening the senses that there is indeed another world out there and that we must help our children to believe and protect this earth in which they live.

Her art is maturing in style, movement and creativity. It now extends beyond fairies and has not gone unnoticed by prestigious business clients. Her imagination and fine detail of flowers has bought commissions for her art on ceramics for The Royal Mint, Brooks and Bentley Ltd and Country Artists Ltd. During Christmas 2004, thousands of her fairies appeared all over the window displays of Thornton's 600 chocolate shops.

Following in the steps of Charles Darwin, Myrea travelled to the Galapagos islands in 2003, the Ecuadorean cloud forest of the Andes and into the Amazon jungle. Her trips have really been influential in developing a deeper interest of flora and fauna and the

**Winter Outfit**    ⌘
*13 x 10 inches. Watercolour and gouache.*

Faeries can get very cold in the winter. The soft and downy dandilion is the perfect flower to use to keep out the chill!

⌘ **Twelve in a Teapot**
*11½ x 16 inches. Technical pen outline, watercolour and coloured pencils.*

These fairies are having a tea party. However, they are about to be rudely interrupted by an uninvited guest. Turn to page 54 to find out who their visitor is.

preservation of endangered species, inspiring her imagination and creativity in her latest works. Did she find fairies in the jungle? Well of course she did, and there were trees there that she had long conversations with, secrets she will not divulge, Fortunately, she never came close to a jungle wolf spider; her arachnophobia – an inordinate fear of spiders – shows clearly in her delightful image of *Anansi*.

Myrea has heard so much about the wonderful Fairie Festivals and Fayres that take place in the US each year. Her ambition now is to make the time to visit from the UK. She gets so many clients purchasing her work from the US, now is the time to go and see for herself and to meet the many wonderful faery artists she has collaborated with.

### Taking a Bumbletaxi
*11½ x 16 inches. Technical pen outline, watercolour and coloured pencils.*

This poacher pixie is taking a ride on his bumbletaxi to catch some fairies. Look on page 55 to see what happens next...

### Anansi and the Sweep
*11½ x 16 inches. Technical pen outline, watercolour and Karisma coloured pencils.*

This little pixie called Sweep is featured with Anansi the spider, who is a popular folklore figure in parts of West Africa.

*"Did she find fairies in the jungle? Well of course she did."*

### Stuck in the Spout
*11½ x 16 inches. Technical pen outline, watercolour and coloured pencils.*

Oh no! The poacher pixie has eaten too many teacakes and treats. Having poked his head into the teapot spout to look for fairies he gets stuck and can't get out.

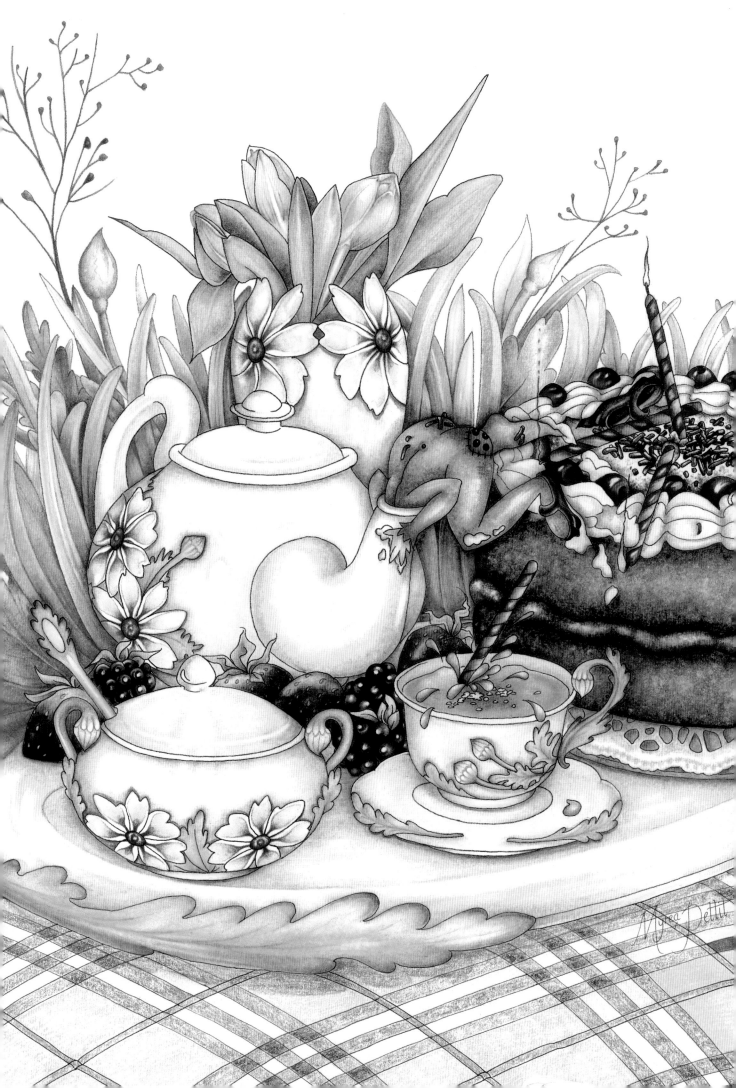

# NATALIA
# PIERANDREI

NATALIE PIERANDREI is still influenced by comic strips and Japanese Manga, but her work is now developing with influences of Art Nouveau. Her favourite tools are still markers and soft pastels, with water soluble pencils. Even though she has adopted dark, dull tones she uses a splash of colour to give a sense of the character's feeling in her drawings. This allows the main figure to stand out, giving greater emphasis of the details of the illustration itself and her improved flow of motion and shape.

In the last two years Natalie has spent a lot of time developing her website www.nati-art.com. She has also become an accomplished web designer, so her site now shows her work more effectively and is very successful in producing worldwide interest in her art, making it accessible for the sales of original paintings, prints, and requests for personal and commercial interests. The world of faery is still her favourite topic, but she has directed her efforts towards other subjects, and that has given her the chance to work on many interesting projects. Currently she is working on several commissions and illustrations, tattoos, covers for magazines, posters for site layouts and even design packaging for a soap manufacturer.

Delighted to have her work featured in this volume she drew her inspiration from legends and fables of her country, Italy, and explains on each the deeper meaning of her illustrations.

### *"Inebriate of Air Am I"*
*9½ x 13 inches. Pantone markers and coloured pencils.*

I drew inspiration from Emily Dickinson's poem for the title of this illustration which was selected for 'Epilogue' The New Masters of Fantasy 2003 CD Rom, in 2003.

On that occasion, I drew many fantasy related images but only this one had inspired me with the world of faery. Being able to fly is a marvellous thing, and faeries know that!

### *Signora dei Camosci (Lady of Chamoises)*
*9½ x 13 inches. Pantone markers, coloured pencils and water soluble pencils.*

The inspiration for this image came from Renaissance painting, especially regarding the dress colours and the pose of the Lady. Ladies of Chamoises are members of Italian Faery Kingdom. They are gentle, loving, joyful, wear sumptuous garments and live in the Alpes among chamoises. They help heroes in their quest and assist the ones who dream of faeries to find the way to the Kingdom of Happiness.

### ♀ *Strega (Witch)*
*9½ x 13 inches. Pantone markers, coloured pencils and water soluble pencils.*

In Italy, legends about *strege* (witches) are more widespread than faery ones in fact. The *Strege* are usually classed among the fallen dwarf faeries, because of their attraction to the creatures of the night. But it is true that most of them watch over trees, nature and they are often mediators between the Human world and the Faery one. They are expert in the seven arts, great scholars of all forms of magic and medicine. Their appearance can vary a lot, depending on local legend. They are thought generally to be diminutive in stature, having a cold, hieratic beauty, or ugly, skinny and twisted, wearing black.

### *Sheer Water in Her Eyes* ↩
*9½ x 13 inches. Pantone markers, coloured pencils and water soluble pencils.*

This is a commissioned image for a client. The faery is represented as a beautiful girl, with little horns in her head (typical of many Italian faeries). I like drawing dresses and garments very much and this faery provided a good excuse for doing that! She is supposed to be a fairy of Cypress, one of the most ragged and distinctive trees in Italy. I think she can influence the fate of humans in the same way a lot of faeries do and she likes living in pleasure gardens.

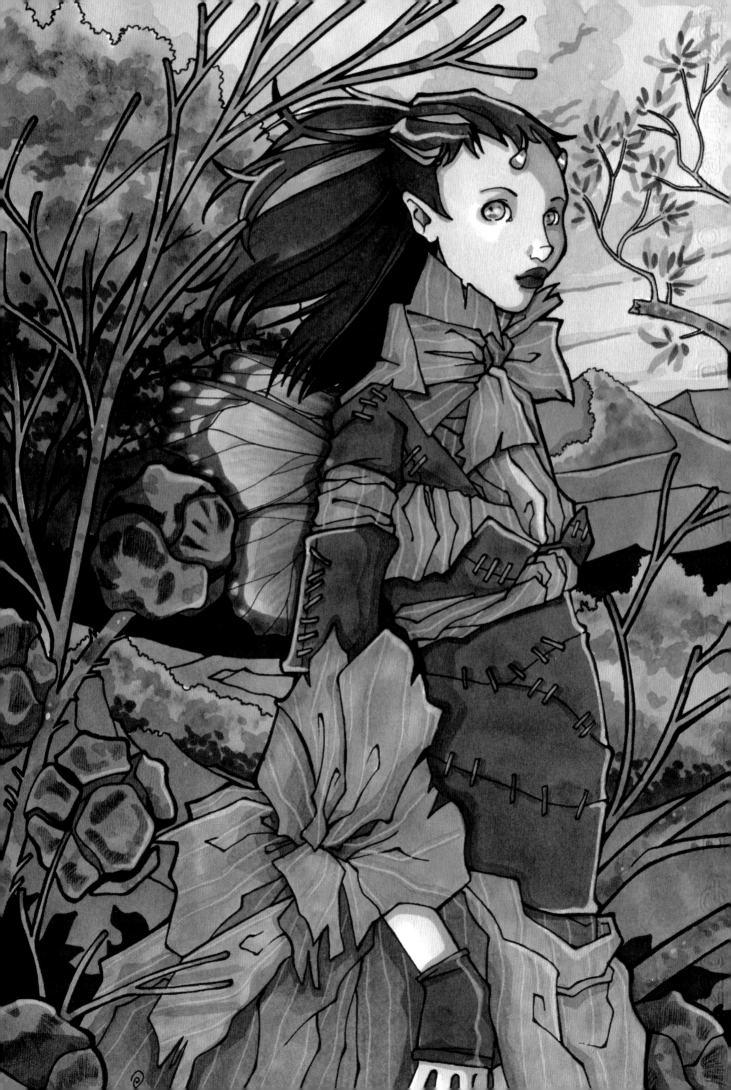

# MARC POTTS

SPECIALIZING in pagan and faery imagery, Marc's paintings are mainly interpretations of nature-spirits, goddesses, gods and faeries. His inspiration comes from dreams, visualisations, folklore, mythology and also from studying nature, both seen and unseen. The spirits of nature may be specific to an element, a place or even a person. He believes that we clothe those spirits according to our own preconceptions, should they become manifest, they would appear different to each observer, but they surround us and affect us without our knowledge. Call them faeries, goddesses, gods or spirits, they live on in the wild places, but they also live in our hearts and minds. If they should fade from our world completely, we would be doomed, as they represent the ancient spiritual forces of nature

"The beauty of the natural world has always inspired my art, I'm lucky enough to live near the beautiful and wild landscape of Dartmoor, a place that has inspired many artists, writers and poets. Devon has a wealth of folklore and mythology and this also plays a huge part for me."

Artistically, the main influences on Marc's style have most definitely been the genius of Brian Froud and Arthur Rackham. However the list of artists that he admire is a long one and would have to include Alan Lee, J.W. Waterhouse, John Bauer and Lucien Levy-Dhurmer. Marc's art has become so much a part of his life that he has to force himself to take time out. Even then he finds himself

↜ *The Changeling*
*25 x 12 inches. Acrylic.*

I find the folklore about changelings slightly sinister and I wanted to convey that atmosphere in this painting. I hoped people would look at the changeling character and get a sense of ancient wisdom lurking behind the eyes. Quite a few people have told me this picture gives them the creeps.

**Blue Faery**
*11 x 19 inches. Acrylic.*

Do faeries have the same emotions we do? I'm never completely sure about that, but this one is a bit sad. I painted her when I was down about something and she reflects my mood at the time. I like her though; she could cheer up at any minute!

*"I get excited when people say to me 'That's it. That's exactly how I see them!' It makes my day when that happens."*

thinking about the next picture, or the one after that. He can get a bit obsessive; it's an all consuming desire to create. "It's what drives me; it's who I am."

He studied art at school, but beyond that has had no formal training, he is what is commonly referred to as a self-taught artist. The truth is that Marc's always learning. As an artist, as with many things, you don't ever truly stop.

Marc now paints mainly with acrylics, as he likes the quality of being able to build up glazes. He reverts to watercolour or gouache from time to time. His palette is a very earthy one, all shades of brown! He does like to add a bright colour sometimes though, just to draw in the viewer's eye. When starting something, he probably spends about two thirds of the time sketching and fiddling about with ideas, and then one third actually painting. Sometimes though, inspiration can strike suddenly and a picture can be fully formed in his mind from the outset. He'll do a few quick thumbnails, some character work, and then dive into the actual painting.

He tends to view his faeries as manifestations of the elemental forces of nature. "I hope this shows in the way I depict them. I get excited when

people say to me 'That's it. That's exactly how I see them!' It makes my day."

Marc does have a message to convey. He certainly has a driving desire to make them tangible and bring faeries back into the consciousness. He wants a story to unfold in the mind of the viewer, something behind the painting just hinted at. We need faeries, whether we know it or not, and they need us, now more than ever. "If I can help in that process in any way, then I will have succeeded."

Marc is always trying to develop, there's no point standing still. He experiments, sometimes successfully, sometimes not. He'll always return to faery though; the call is too strong to ignore.

### ⬸ *Moonpearl*
*13 x 10 inches. Gouache.*

This character originates from a recurring dream I used to have as a child. Moonpearl is just one version of the 'twiggy-haired hedgewitch' entity that I've painted and drawn many times over the years. I think she may have started the whole thing for me.

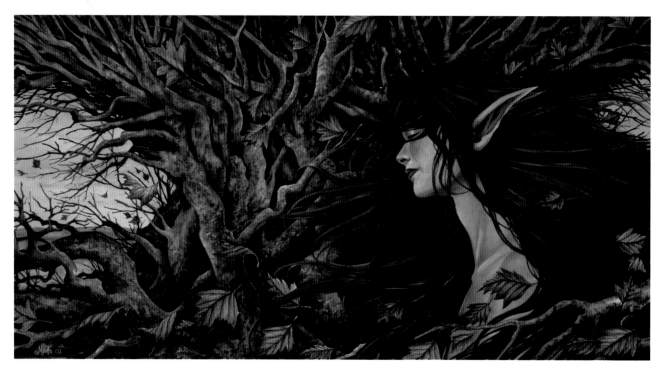

### ⬙ *Autumn Splendour*
*12 x 19 inches. Acrylic.*

This picture was painted as part of Duirwaigh Gallery's 'A Tribute to Arthur Rackham' exhibition. It was inspired by a windy autumn day on Dartmoor and was one of those pictures that came to me suddenly, fully formed in my head. I temporarily dropped other projects to paint it.

### *Old Ginny* ⬯
*12 x 8 inches. Watercolour.*

This is a very Rackham-influenced piece. There's a story in my head behind this character; It's about an old witch that makes a goblin boy out of the things she collects as she wanders the woods and moors. I used to tell the story to my daughter at bedtime, basically making it up as I went along.

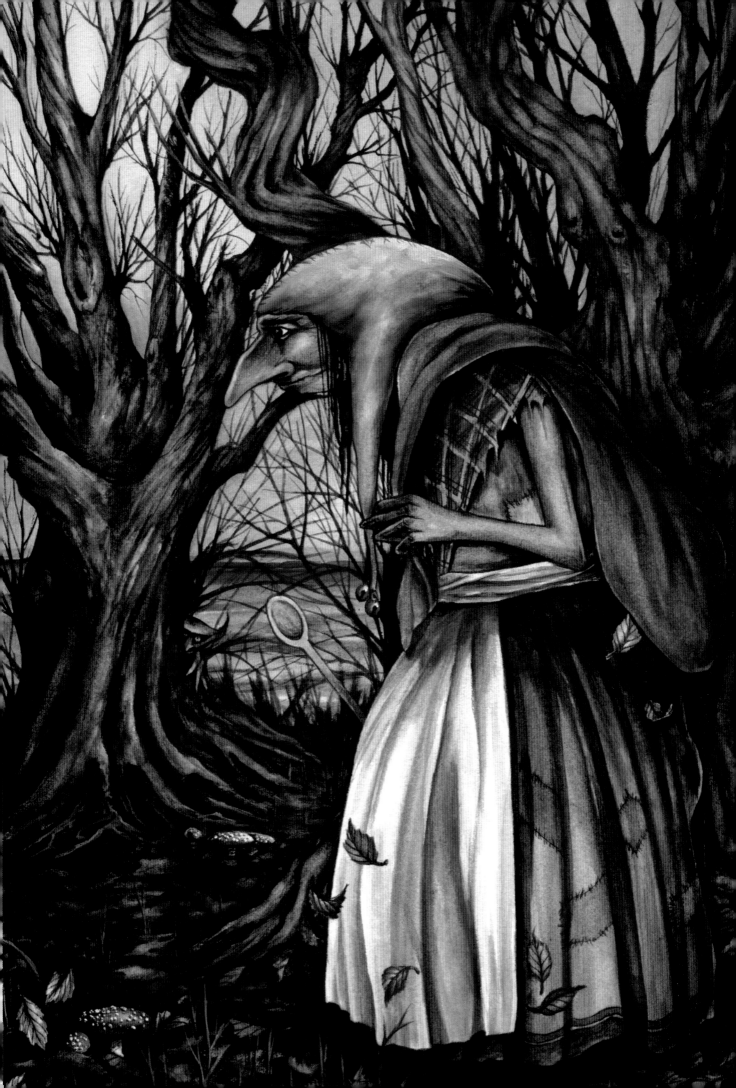

# STEPHANIE PUI-MUN LAW

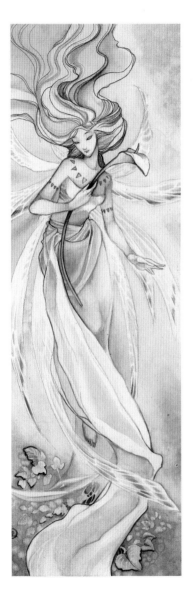

STEPHANIE PUI-MUN LAW is a freelance artist, whose work consists of fantasy, the otherworld, and the surreal. She has been illustrating since 1996. Stephanie graduated from the University of California at Berkeley in 1998 with a double BA degree in Fine Arts and Computer Science. She was well on her way to a lifelong career in programming in the Silicon Valley software industry, before she was sidetracked by the will-o-wisp lights of painted faery creatures, and the memory of where her passions truly lay.

Much of her inspiration comes from mythology, legend, and folklore, and her art seeks to find a whimsical kernel in reality. She has also been greatly influenced by the art of the Impressionists, Pre-Raphaelites, and Surrealists, along with current popular fantasy artists. What Stephanie tries to convey with her art is not simply fantasy, but the fantastic, the sense of wonder, and that which is sacred.

Stephanie was born in New York, but has lived in Northern California since she was seven and loves it there and currently resides in Oakland. The only thing she sometimes misses is the lack of clear seasons. Although she doesn't ever really notice until she travels – for example on a visit to Japan in November several years ago. "I was just amazed by how the landscape was lit up with the flaming colour palette of autumn. The hillsides near the temples glowed with the fallen gingko leaves, and the red maples. At times I felt I walked through an outdoor cathedral with the sun coming through the leaves like the panes of stained glass." In fact, the memory of that has been a

### Lily II
*3½ x 10½ inches. Watercolour pan paints.*

This was commissioned by a client who loves lilies. I attempted to depict the faery's form as reflecting the shape and grace of the lily she holds.

### Chess Mates
*16 x 22 inches. Watercolour pan paints.*

What else is there to do while idling away the hours in a forest? In part, the inspiration for this piece came from a spot just a few blocks from where I live. Every morning, the elderly Chinese men meet there to play Chinese chess. There is always a crowd of onlookers looming over the two or three pairs who are actually playing. The spectators offer advice and comments in a constant flow of musings and head-scratching. All the while, the players themselves are oblivious to the world around them, caught up in the game. Who knows what games the fae entertain themselves with when no human eyes are watching?

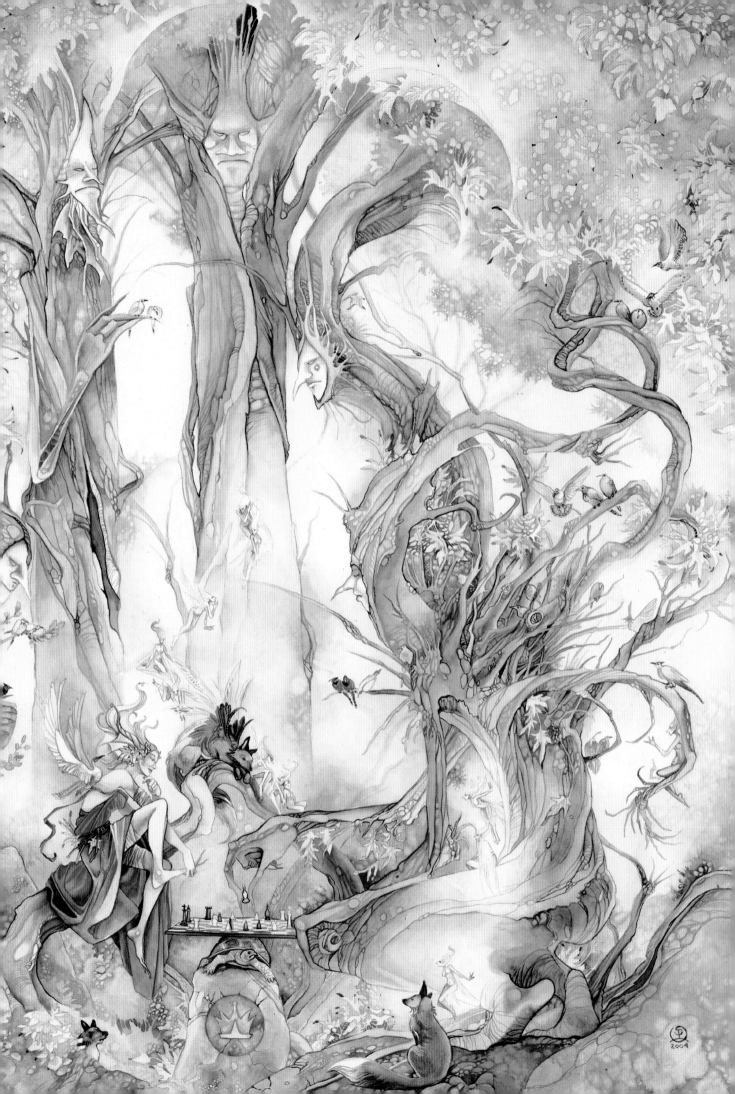

great influence on the colour schemes of the foliage in much of Stephanie's work. For her, those colours invoke an otherworldliness.

She continues to build her reputation as a fantasy artist and has been working on several book covers for Harlequin's new romantic fantasy imprint. Her own book, full of her art illustrations was finally completed and released in the fall of 2004.

Her creative fun is in designing game art, and having successfully established herself in this genre she is asked frequently for images for role playing games. This means she can be found at numerous conventions, Gencon in Indianapolis, Dragoncon in Atlanta Georgia, and she even goes as far as Essen, Germany, for an enormous game convention there called Spiel. Between those and other west coast conventions, from Seattle down to San Diego, she had eight convention and personal appearances in 2004.

Stephanie's artistic views and techniques have not particularly changed, though she feels she is improving with each new painting produced, and that always satisfies her. Her favourite piece is always changing, usually to her most recent pieces, which she feels is a good sign of her evolving work! Though Stephanie still works mostly in watercolour on illustration board, she seems to be spending more time using the smallest brushes and

*Friends III*
*5 x 6 inches. Watercolour pan paints.*

A light-hearted and whimsical piece. The delight of a new discovery and sharing.

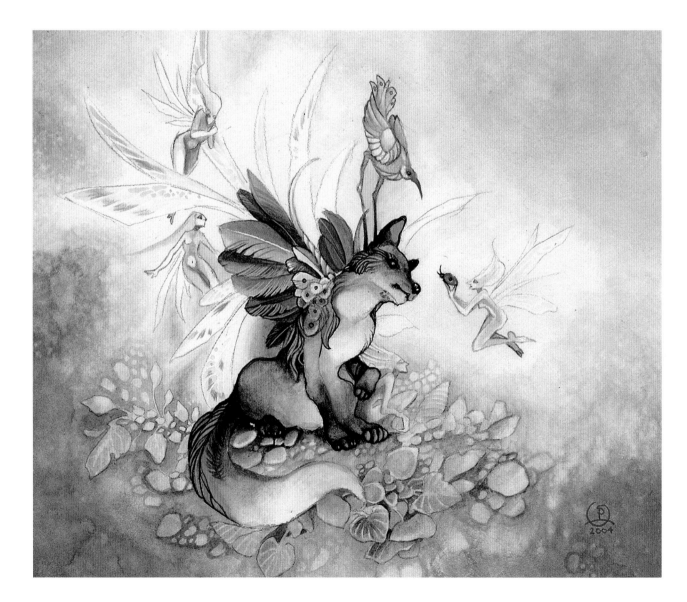

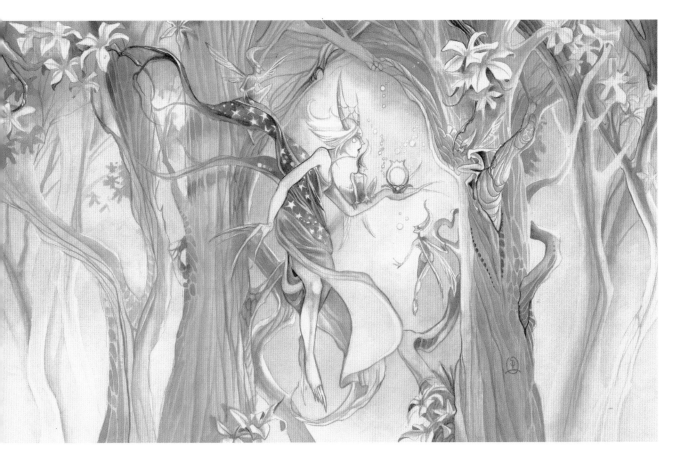

> "What Stephanie tries to convey with her art is not simply fantasy, but the fantastic, the sense of wonder, and that which is sacred."

✿ *Seasons: Summer –*
*Night Blooming Flowers*
*9 x 16 inches. Watercolour pan paints.*

This is an image of memories; of long-ago nights when I was young, running after fireflies to catch them in a jar. They glowed in our cupped palms, but they always stopped winking their lights not long afterwards, and so we would have to set them free. More recently, there are trees outside the subway station where I live. In the daytime, they are just trees, but on summer nights the flowers bloom, and when I take that first step out from underground, the scent hits me so suddenly and undeniably. That delicate fragrance tells me that I have arrived at home, and I always stop and close my eyes and breathe deeply before walking slowly to my apartment.

applying more fine details. "I like to create a piece in which the eye is constantly travelling and moving around the composition to find new points of interest. I want the viewer to find something new every time they look, that they did not notice before." She greatly enjoys doing pencil drawings as well, as it is good to switch over when she needs a break from the brushwork. Stephanie does the occasional digital image, although she prefers to have a piece of traditional art to hold in her hands at the end.

She updates her website http://www.shadowscapes.com with her new work and has started adding a lot of her smaller black and white drawings and sketches. Included are a few tutorials and step-by-steps to show how her images are created, something that she gets many requests for. Books like *The World of Faery* have provided a great forum of interested readers and encouraged visitors and artist friends to visit Stephanie's website.

# COREY J. RANDALL

**C**OREY WAS BORN and raised in the suburbs of Philadelphia, Pennsylvania. However, after doing some travelling around the country, he is currently living in a small artistic town in the mountains of North Carolina. He has been doing some form of drawing or painting ever since his early years of nursery and elementary school; his father would often tell of how he once used nail polish to redecorate an antique telephone at the tender age of two.

Corey has always had a love of nature, especially anything involving creeks and streams, as well as the personality and characters of old, gnarled trees. "I think that one of the reasons I paint is that it gives me a sense of purpose in life, a focus and direction. I've also had many people compliment me on my art so that I'd almost feel as if I'd be wasting a gift if I didn't do something with it." After focusing on art throughout his adolescent academic training, Corey received his Bachelor's Degree in Fine Arts from a small liberal arts college in 1997.

☙ ***Around the Sycamore Tree***
*11 x 14 inches. Watercolour, pen and inks.*

Another attempt at the more ethereal style. Every time I look at this painting, I can almost hear a Celtic reel playing, encouraging the faeries to race around the base of the tree in an ever faster-growing dervish.

***Tucked Away***   ☙
*15 x 22 inches. Watercolour.*

Sometimes the reference photos that I like the most are the ones that are unstaged and that capture a gesture that is completely natural. In this painting the image is of the model settling her position in the tree, She was taking off her glasses for the shoot and tucking them away in her vest.

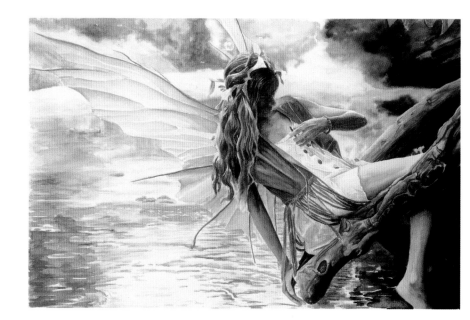

### *Awakening*
*16½ x 11½ inches. Watercolour.*

They say every picture tells a story, this one felt like someone starting a new day. For some reason, I feel as though there's a sense of optimism in this painting.

Primarily, Corey uses Winsor Newton Watercolours, cold press paper that doesn't have too much texture that may interfere with his work, and some old Robert Simmons brushes that he's had since college. His colour palette generally stays in the range of earthy pigments, with some occasional sharp reds and blues to add life to the piece. He always seems to be running out of Burnt Sienna.

Recently much of Corey's work has been based on photography. As he can never get his friends to sit still long enough to model for him, he takes photographs instead. "From any given photo shoot I'll take a dozen or so images that really sing for me, tuck them into my sketchpad until they evolve, then construct a highly detailed pencil outline of shapes and colours on the watercolour paper, and start filling in from there." The first part of Corey's drawing stage is to get the energy of the figure translated properly into the lines. From this point he works out the structure and positioning of the faerie wings envisioned in his head, examines how their shapes balance with the rest of the figure and how they'll fit compositionally onto a page.

Corey mainly works for himself. "I've taken on a few private commissions from time to time, but generally I like just being in charge of the direction my artwork goes in." Over the years he's picked up a handful of different awards in Art shows and galleries; for Best Aspiring Professional, Best Watercolour, and Best Fantasy Artist. Unsure of what the future holds at this point, Corey is happy to be painting, travelling and keeping a roof over his head.

# LINDA RAVENSCROFT

Linda Ravenscroft is a self-taught British fantasy artist; she has been painting and drawing fantasy subjects ever since she was a child.

She lives in the rural county of Cheshire in England, together with her husband John, daughter Vivien and numerous family pets. Her work can be seen all over the world and her intricate designs have been used for a number of licensed products and gifts.

For Linda, painting fairies is a way of escaping this sometimes terrible world, a place of retreat, her way of shouting out to mankind. "In my paintings I try to express some message of hope or a warning of things that might be if we don't look at our world in a new light, to take more care of Mother Nature and not take her gifts for granted".

The idea of the Faerie folk or earth spirits, call them what you like, dates back as far as time itself. These beings have been mentioned throughout the history of mankind, bringers of good and sometimes of mischief and woe. To Linda they represent the natural world we live in and whether you choose to believe or not, they do have a place in our modern day society. As a faery artist, Linda expresses so poignantly and beautifully in her art, the seriousness of the message and the passion she feels for the frailty of the world. Her art urges us to educate our children to take stock of what damage we are doing, and perhaps if we truly believed in the fairies as our ancestors did, we would show our planet a little more respect.

Linda believes we all have a little bit of Faerie magic within our hearts helping us to make the right decisions

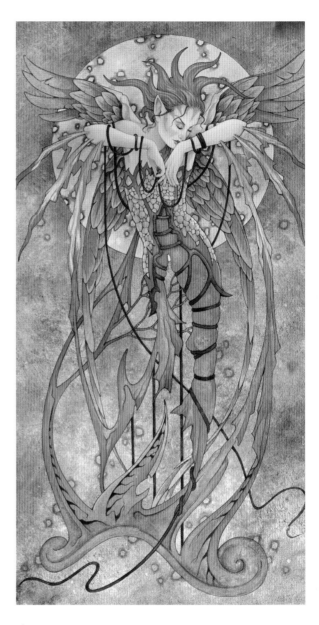

φ *Phoenix*
*13½ x 19½ inches. Acrylic and mixed Media on paper.*

I painted this because I needed to. After a period of disappointments and sadness the sun had begun to shine for me again, and a friend of mine had been through a traumatic time... I decided we needed a symbol of strength so that we could look to our future with optimism and joy. And this was the result. Quite uplifting, I hope.

in our lives. "I hope that my paintings will help people, and make them stop and think a little, yet still find some comfort and hope within their everyday lives."

A typical days work for Linda begins after taking her daughter Vivien to school. She then takes a large cup of tea to her place of work. Her studio is only a few feet from her home, and was lovingly built by her husband and her father. "It's a place where I feel very comfortable and happy, it overlooks my garden and the small wood which is just next to our home, and offers me daily inspiration." Linda's head is always full of ideas and she sometimes sits and sketches them out or continues with a piece of work she's already been working on. Her husband usually has to remind her to have some lunch otherwise she would probably work right through. After her daughter Vivien returns home from school, Linda will break and then prepare their evening meal, after which she returns to work. Linda listens to an eclectic mix of inspirational music, from classical music, to modern groups such as the Mediaeval Babes, Levellers and Coldplay, to name but a few. "Music is very important to me, like art it can be interpreted into whatever the listener can visualise in their mind." Linda often work through into the early hours, sometimes until dawn, finding it so easy to be beguiled by the fairies, and lose track of time.

Linda's favourite medium are watercolours, and she has played with them since she was a child, trying to master their use, and will keep on trying and experimenting. She loves the way the colours can be so translucent and yet by building up layers they become so vivid. She also enjoys the way the

⚘ *Field Fairy*
*10 x 10 inches. Watercolour.*

Resting amongst the poppies on a summer's day with lots of faerie friends and two little harvest mice for company, what more could a fairy ask for. I used pen, ink and watercolour for this image. Here in the UK the harvest mouse is an endangered species due to the use of pesticides and mechanical farming. However, thanks to the return of organic farming and a little help, they are now being re-introduced in certain areas.

⚘ *Necromancy*
*8 x 21½ inches. Watercolour.*

The white fae mystic wears a ritual headdress, designed with green leaves to offer a welcoming prayer for the return of spring and new life.

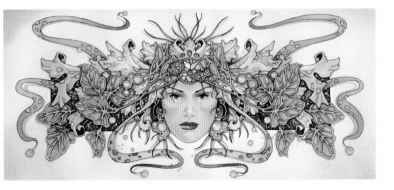

*"For Linda, painting fairies is a way of escaping this sometimes terrible world, a place of retreat, her way of shouting out to mankind."*

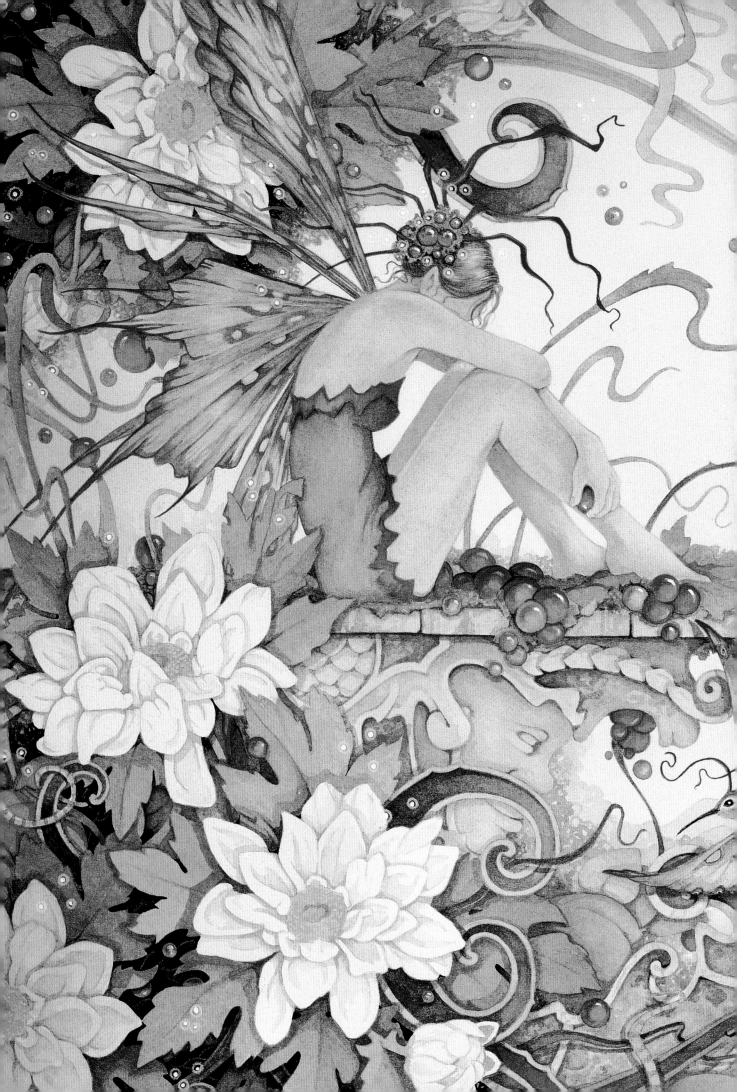

*"Everyone loves to sit in a garden.*
*Faeries are no exception…*
*Transport yourself into a place of*
*peace and tranquillity,*
*a sanctuary for those who dream*
*of better things, a place to relax*
*and let your fears drift away."*
Linda Ravenscroft

*The mystic garden*
*15½ x 21 inches. Watercolour.*

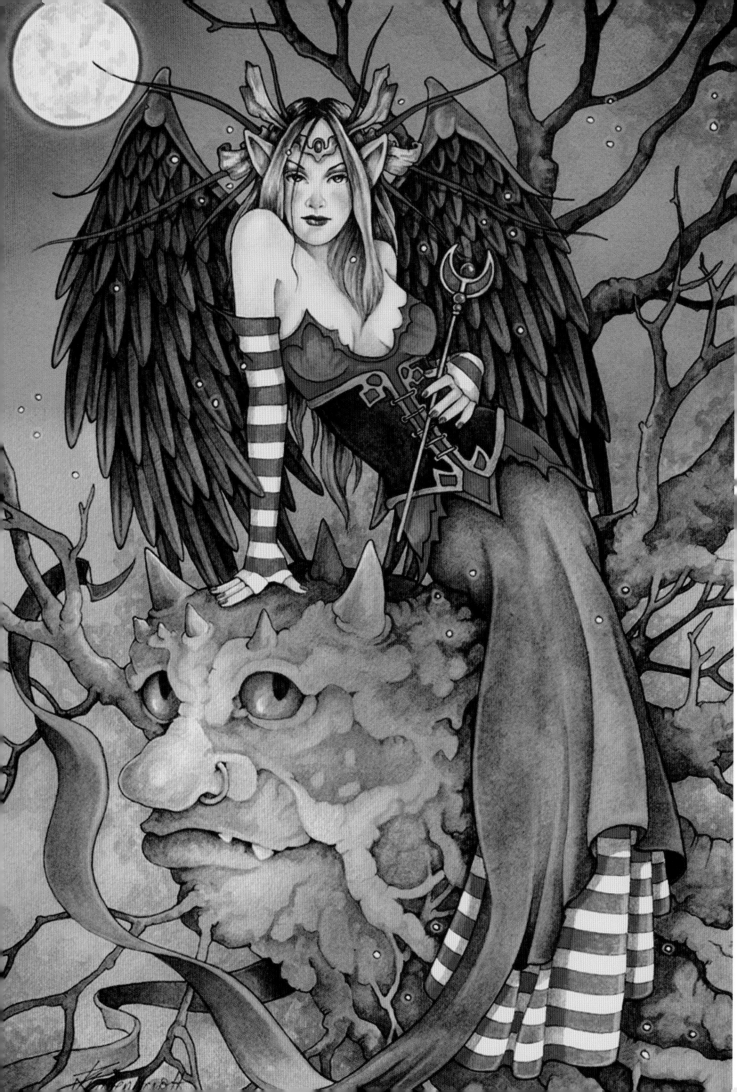

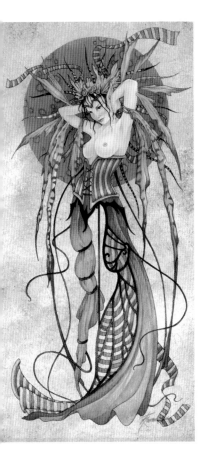

water causes the colours to bleed into wonderful shapes and natural forms. The only downside is that unlike oil painting, which can be corrected again and again, if you make a mistake it can sometimes be impossible to repair and you have to start all over again. Linda also loves to sketch with ballpoint pens and ink pens; as they are so easy to carry around and enable you to draw something whenever the mood takes you.

Linda's images have been published in several books, including *The Art of Faery*. Linda is currently writing her own book which is aimed at helping all those who want to express themselves in an artistic way, and to unleash their imagination and feelings through the Art of Fae. Linda has recently released a number of new fine art prints with her publisher www.duirwaighgallery.com in the USA.

### Witching Moon
*14 x 23½ inches. Acrylic and mixed media.*

An enigmatic, seductive fae paying homage to the blood red harvest moon, the witching moon. I like to paint erotic subjects, its simply another part of the human psyche and another way to release inner feelings. This image has been painted with acrylic and other mixed media, it is a more liberating and much less intense way to paint, unlike some of my other more detailed watercolours.

### The Goblin Tree
*8 x 12 inches. Pen, ink and watercolour.*

In the light of a full moon, a dark gothic fairy sits upon the Goblin tree. I love to give trees personalities after all they are living things and deserve to be seen as such. This one is a wise grumpy old tree with a wicked streak, hence the name *The Goblin Tree*.

### Marked one
*10 x 14 inches. Acrylic and mixed media.*

I recently had a tattoo. Not for vanity, (well maybe a little) but as a rite of passage, a symbol of what I now was, an artist. After many years of doing jobs I hated, I was now finally doing what I had been born to do. So, I decided to have something permanent to remind me of how far I had come and that there was no going back, no matter what. This painting is about a faerie who also knows who she is; one of the wise ones, her tattoos are symbols of her past, present and future, and her dedication to Nature.

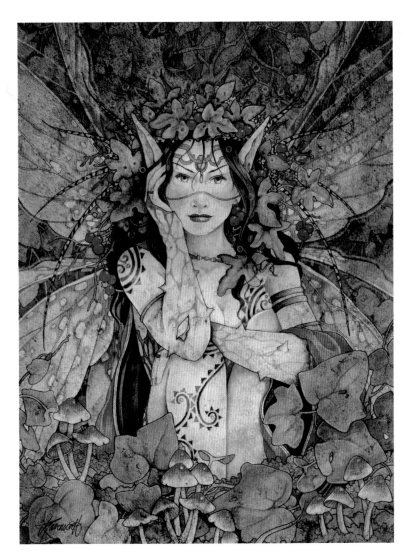

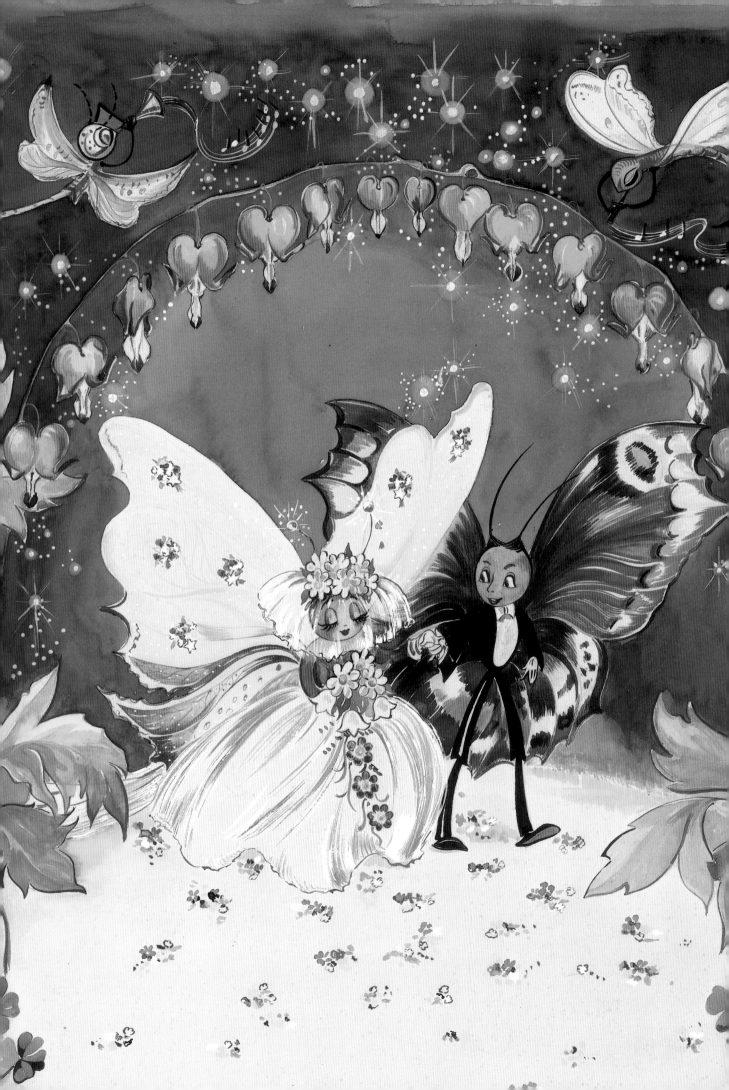

# ANN MARI SJÖGREN

ANN MARI SJÖGREN, now 86, illustrated about twenty children's books over the course of sixty years, many of them about fairies; but then seemed to suddenly retire. *A Day in Fairyland* (*En dag i Älvriket*), her most famous book, was published in 1945, translated into ten languages and sold throughout the world – perfectly coinciding with the boom in interest about fairies following the second World War.

Through her website www.fairypaintings.com Ann Mari has received many messages and greetings from readers – mostly women – in the US and UK. As small girls, they all have strong memories of the pleasures her pictures created, and explain how much the book has meant to them. Just reading and being reminded about Ann Mari now bring vivid visions of their own beloved parents and family to mind. These are testimonies for how good art can strengthen a person, and can be of help in difficult times, to give joy, and promote imagination.

**φ  *For love***
*6 x 6 inches. Watercolour*

Ann Mari Sjögren was born in Nyhamnsläge in 1918 and now lives quietly, in a cosy attic apartment with a view over the Öresund strait in Sweden. Her home is filled with art of all kinds, many of which are of course her own. Ann Mari has lived a quiet life now for many years and has hardly seen her book since it was published, so was quite surprised at the fuss and nostalgia that surrounds it.

Ann Mari owns a cabin near Lake Västersjön in northwestern Skåne [Scania], where her and her husband Stig (now sadly passed on) spent much time. It was here that nature and the environment inspired her, and can be recognized in her fantasy landscapes. Ann Mari had once sat drawing on a stone as a dragonfly passed by with its light blue, striped body, and this was her inspiration for the illustrations in *A day in Fairyland*.

From then on, her fairies became small girls with blue striped shirts and light small wings on their backs. Normally fairies are depicted as fragile beings, dressed in white, dancing at dawn in the dew-sprinkled grass. Her

**⟡  *From Wedding Bells in Fairy Land***
*13½ x 19½ inches. Watercolour and gouache.*

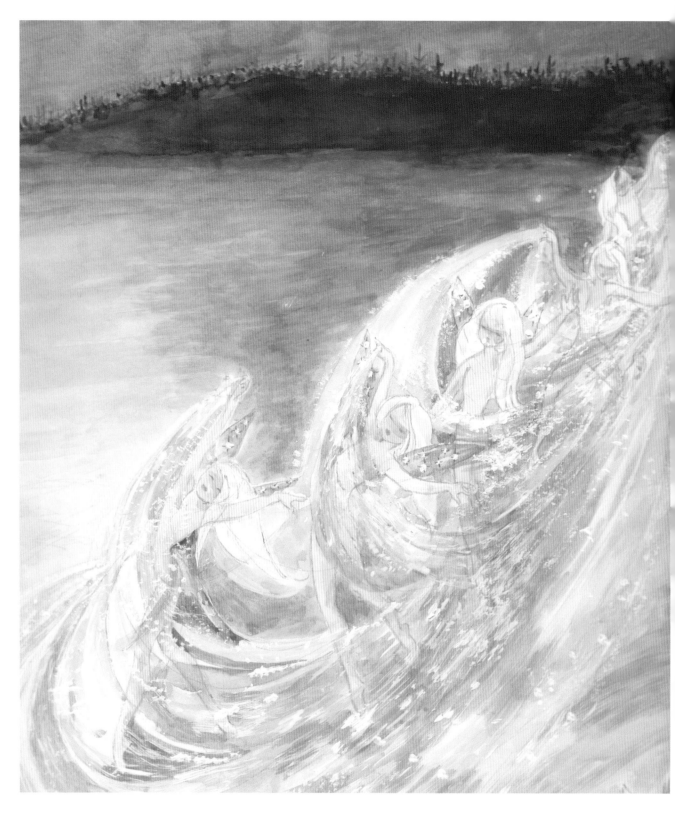

### ♠ *Fairy Dance in the Mist*
*12½ x 17½ inches. Watercolour.*

This is an original from the 1960's intended for the cover of a
Fairytale book. The book was refused, but I kept the picture, and it
served as inspiration for a picture in *The fairies go to school*
presently under production.

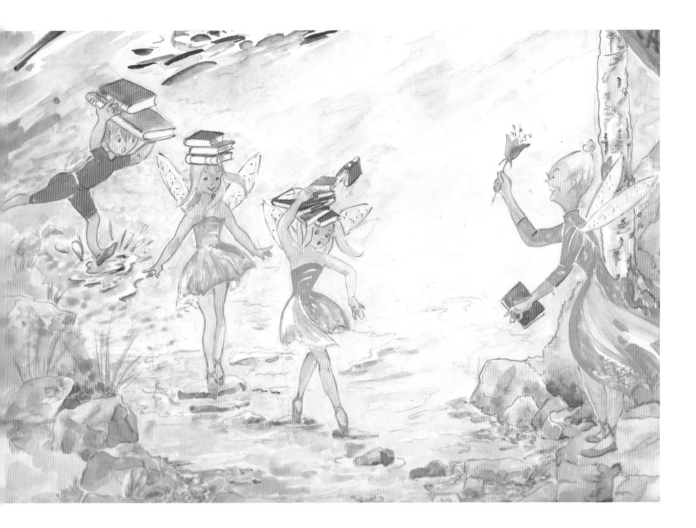

*The Fairies go to school –
History lesson*
*11½ x 16½ inches. Watercolour.*

creations are far more robust. Ann Mari has filled the desk in her study with clippings, illustrations and fairy books of all kinds. Among them is an old press clipping with an advertisement from an American paper, showing the once so famous actress Joan Crawford, reading aloud from *A Day in Fairy Land* to her four adopted children.

In her early days as an artist, Ann Mari found drawing at home lonely work, therefore she began to work as an art teacher from time to time. Eventually she became discouraged by the mischievous children and turned her attention to teaching adults. She found the adults more keen to learn and would teach different art techniques, for example croquis or batik.

Ann Mari is still very much in touch with the Land of Fairies and is still as popular as ever. "If I keep on for a while, I guess there will also be 'The pensioned fairies".

# WENCHE SKJÖNDAL

WENCHE SKJÖNDAL was born in Bergen on the west coast of Norway. The Bergen landscape is dramatic with high mountains, fjords and rivers. She has spent hours and hours here, climbing the high passes and walking the wonderful valleys. The atmosphere and nature there is so full of life and magic that it is no wonder the Swedish people have always been strong believers of tales and folklore.

In the evenings, Wenche and her siblings would all gather around their mother as she told them tales about the cruel trolls and witches lurking in the woods. The stories were so vivid that she lay awake late at night picturing the trolls in their caves up in the mountains. She was a shy little girl but nevertheless curious. She liked to stroll and discover the world around her, letting her thoughts and impressions come alive on the canvas.

Her children, together with the landscapes of her youth, are some of her strongest influences. She also loves music and movement – for Wenche the fairies are nothing but dancers, living for the perfection of movements; symbolic of nature. Wenche made her first fairy paintings only a few years ago. She was sitting in the rose garden in Gothenburg, as she loves to do, in the summer, and was just about to paint a beautiful yellow rose when suddenly she saw her redheaded daughter through the leaves. "She was smiling at me and she looked so at home next to the roses that I decided to add her into my picture. I turned her into a little rose fairy and the colours were such a perfect match, it added that final touch that gave the painting a bit of magic"

Wenche starts out by first sketching the fairy, then she creates suitable surroundings. Such images are not bound with rules so she often finds her painting changing both direction and colour scheme. She adjusts and follows her feelings as the image develops, finding this way of painting to be the most exciting, since not even she knows exactly what the end result will look like. Her small paintings are in watercolour and gouache, and the bigger paintings are in acrylic or tempera. Now, Wenche is very eager to paint pictures for all the fairytales she told her children when they were young.

### ✤ The Bee
*9 x 9 inches. Watercolour.*

This is one of my favourite paintings, a little girl very sweet, very afraid of bees. I wanted to show her fragility so I used very thin watercolour and spared out the white paper in the dress and wings.

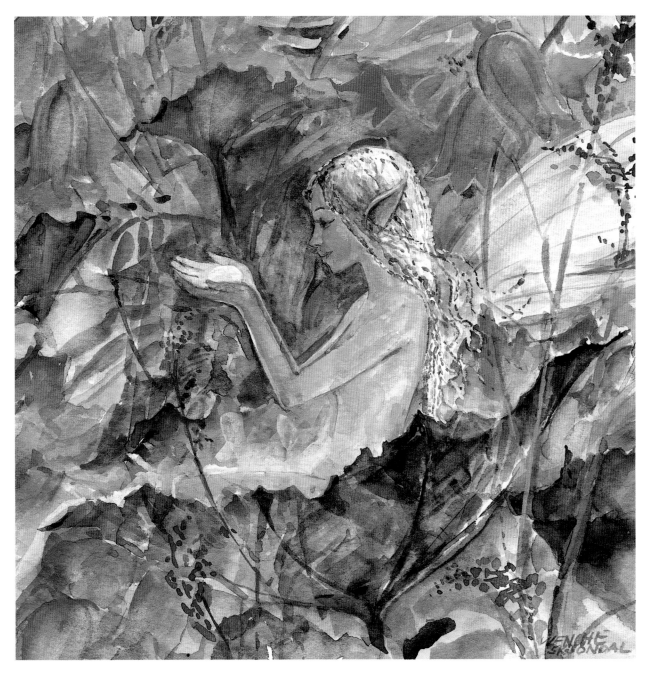

### *After the Rain*  ♀
*7 x 7 inches. Watercolour and gouache.*

My fairies are often very small, innocent and shy,
living in peace and harmony in the foliage, a
magic creature blending among the leaves.

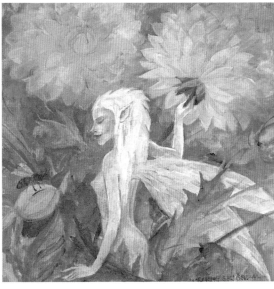

☞ *Summer*
*7½ x 7½ inches. Gouache.*

My eldest daughter has always that lustful
and content smile when there is something
she likes. The winter is to dark and long here,
summertime is so joyful.

# JEFF SPACKMAN

From what Jeff's been told, he's been drawing ever since he was old enough to hold a pencil. He cannot remember his first attempt at art. Nature is his first and most important inspiration. Secondly, his inspiration comes from the cultures and mythology of the world. Jeff's travels have helped to kindle his imagination and inspiration. "Once in Crete in a grove of ancient, extremely gnarled olive trees I came upon marble columns tumbled about and pieces of terra cotta crumbled under my feet as if they were gravel."

Jeff's 'training' consists of merely painting and learning something from each painting he creates. He actually studied zoology in college which may be evident in some of the references in his paintings.

He paints with acrylics using tiny brushes, and sometimes he fears he's on the verge of carpel tunnel syndrome! Occasionally he uses an airbrush to create a particular effect. Jeff prefers to use the colours of nature, in which there can be the juxtaposition of the muted browns of a tree trunk right next to the flaming violet of a hummingbird. It sometimes takes Geoff weeks to finish an art piece.

Before creating fantasy art, Jeff illustrated a few children's books, including *Eek! Stories to Make You Shriek* and *Boo! Halloween Poems and Limericks*. He doesn't just paint fairies, but also magical beings in natural settings. To Jeff, nature is a magical faeryland. "I get infuriated when I hear

### ⤶ Cathedral Forest
*11 x 17 inches. Acrylic.*

People often tell me "This is our church!" when seeing the *Cathedral Forest* picture. Why not? If one believes in God, then surely a forest of ancient trees is one of God's own cathedrals. The towering columns of the ancient trees and the hushed atmosphere inspire an awe much like walking down the nave of a Gothic cathedral. I live in Oregon where there are no true Gothic cathedrals. Instead there are forest cathedrals, the likes of which no human hand could ever build. Surely this is Faeryland, a place to hug a tree and listen to its secrets

### Iris Queen ⤷
*11 x 17 inches. Acrylic.*

When creating an image I will usually start with a small seed of an idea, which gradually sprouts into a fully-developed image. For example, in my painting *Iris Queen* I wanted to create an intricate design of a spider web based on the geometrical designs of Islamic art. Next I pondered, "who might have such a throne room?"

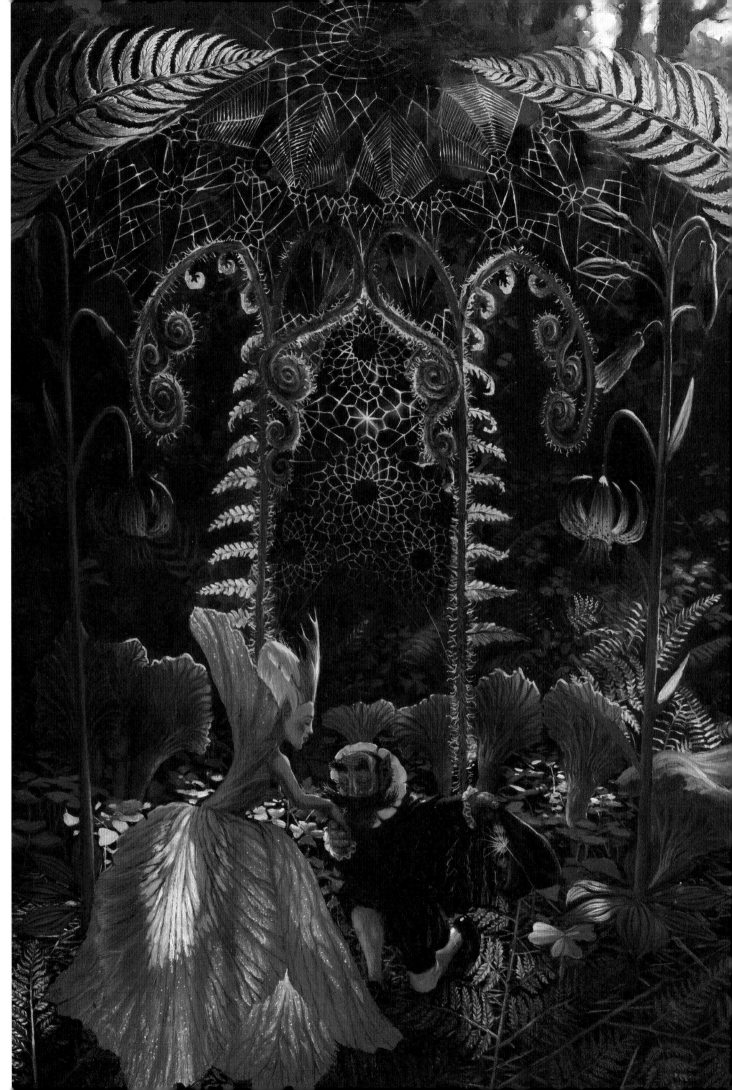

talk of spending countless billions of dollars on a possible journey to Mars, when right under our noses is the most amazing place we will ever the have a chance of exploring, and we're in the process of destroying it!" Jeff agrees with the eminent biologist E.O. Wilson, who said (whilst holding a handful of rain forest soil) "There is more complexity in this one handful of soil than in the entire non-terrestrial solar system".

In the future, Jeff wants to use magical, metaphorical picture books that convey a message about this precious, amazing planet we live on, our very own faeryland.

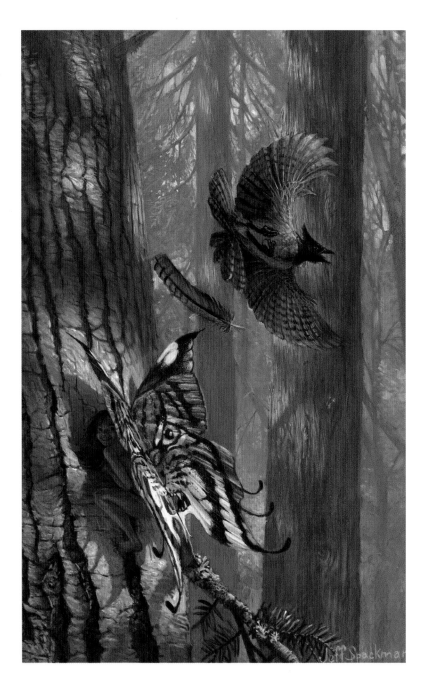

↜ *Trickster*
*11 x 17 inches. Acrylic.*

The picture window of my apartment building, which is also my studio, faces a large forest of firs, maples, and hemlocks. This is my daily inspiration to paint!

**Black Orchid**  ♧
*30 x 40 inches. Acrylic.*

I've also been camping in the Amazon jungle,
which partly inspired my *Black Orchid* painting,
although this particular painting takes place in
Central Africa.

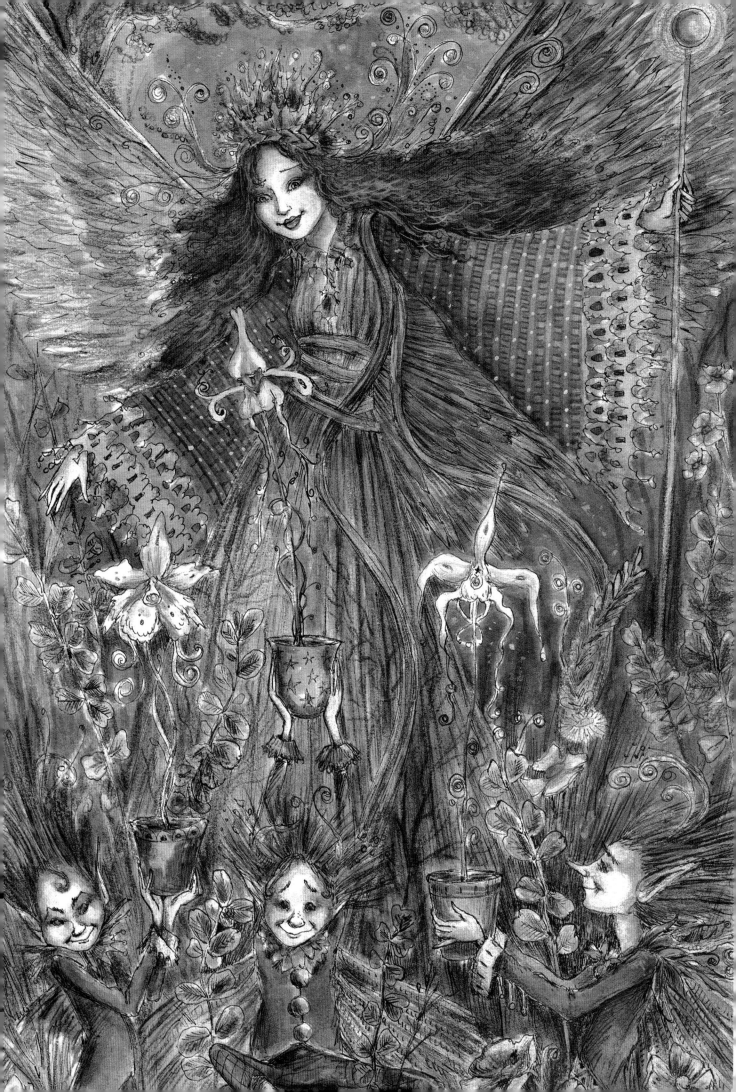

# PAULINA STUCKEY-CASSIDY

PAULINA'S LITTLE PEOPLE have enchanted so many from her faery world. Paulina believes that nature's spirits inhabit our space in time. They're as natural as that which is seen with the naked eye, yet they reside within 'the invisible world'. "They are spirited little scientists, working in unison with the earth's abundant energies. They're shape-shifters; highly evolved spiritual forms who are ingenious tricksters." If you seek them beyond physical sight, you may be surprised to find that they are closer than you expect.

The nature spirits share their book of secrets with Paulina, a book which is filled with endless inspiration and awe. Their presence is a blessing. "Their playful energy abounds and sometimes overwhelms my senses to a point that I feel I'm one of them." She feels that the spirits, in their excitement, can at times be demanding to the point of exhaustion. Though they're loving and gentle, they can be pushy at times. Paulina know's they'd be happy to see her drawing and painting twenty-four hours a day, creating a constant flow of art with depictions of their realm. Sometimes she needs to remind them that she can only do so much at once – time here is very different from theirs! Luckily, they're very understanding. Here is a selection of Paulina's delightful work for you to see.

### Rare Orchids for the Faerie Queen
*9 x 14 inches. Watercolour and ink.*

The Krewe of Enchanted Elves eagerly anticipate the majestic arrival of their Faerie Queen. She holds within her being the essence of divine mystery, weaving the sun-kissed breath of life into the plant kingdom. The Elves offer her a gift in return, by presenting her with the finest of healing orchids, finely imprinted with her touch and their tender loving care.

### The Magic Pear
*8½ x 11 inches. Watercolour and ink.*

Trees communicate with nature spirits, for they contain their very own spirits which interact beautifully with faeries. The fruits of trees behold their spiritual energies and in turn offer great nutrition if taken with gratitude and respect. As his branches twist forth in the autumn winds, this pear tree offers his most cherished sun-ripened pear to a wandering faerie, an essential gift of life-force.

### ✌ *The Luminous Return*
*8 x 10 inches. Watercolour and ink.*

"For those who are mesmerised by the calming light of a candle"

Her candle flickers for all who seek –
A tiny light breaks through the fog;
Long lost treasures will be found again.
The flame extends its arms of fire,
delivering the spark of merriment to a kindly heart.
O, welcome, the luminous return.

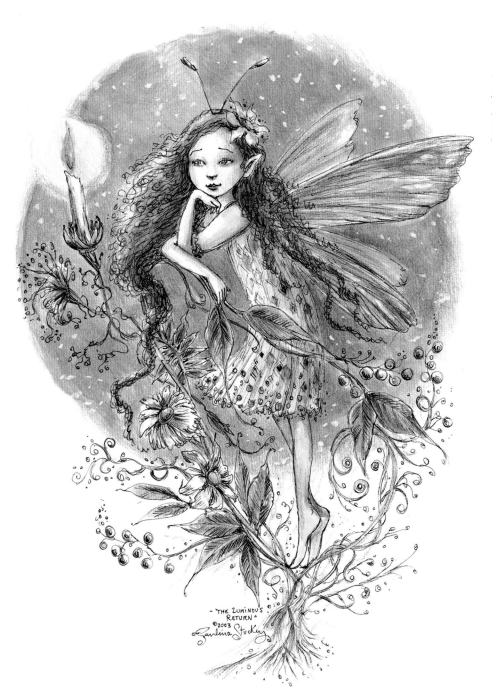

*"They are spirited little scientists, working in unison with the earth's abundant energies. They're shape-shifters; highly evolved spiritual forms who are ingenious tricksters."*

### *Night of the Presencia Woods Ball* ✌
*11 x 14 inches. Watercolour and ink.*

"For those who love an outdoor gathering filled with mystery and magic"

Messieurs, Mesdames et chers enfants,
Laissez les bon temps roulez!
Carnival Season has sounded her call!
Powder your noses and dust up your wings,
Then head to the spot where grows faerie rings!
This night we go to the Presencia Woods Ball!

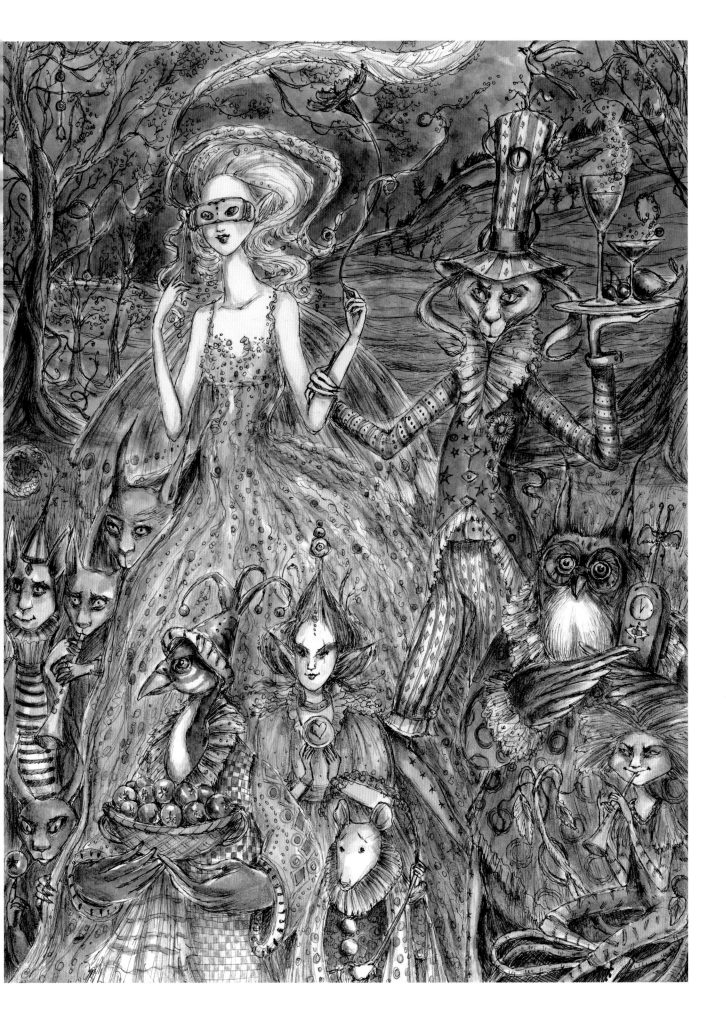

# JANE SULLIVAN

J ANE SULLIVAN RESISTS the tendency to label herself with a profession. She believes, as Hermann Hesse expressed it, that our genuine vocation in this world is to find the way to ourselves and if, along the way, we become poets or madmen, prophets or criminals, that is entirely incidental. She doesn't object to being called an 'artist', as long as it can be simply one facet of a complex, yet hopefully homogenous, whole! Asked once, at College, to produce a CV, she showed the finished document to her professor, who regarded her myriad of interests and occupations with disbelief: "This cannot be one person!"

Despite her discomfort with titles and the risk of being pigeon-holed, if asked "what do you do?" (above all if the inquiry seems too prying!) she tends to reply, "Oh, I'm an insular palaeographer"; it being indeed true that she holds postgraduate qualifications in medieval manuscript studies, but this response normally stumps her interrogators as well. At UCLA, she was good-humouredly accused by fellow MA students of having absolutely no practical career aspirations. "You don't want to become a professional folklorist or lecturer in Celtic Studies, you want to be what you study: a Celtic reflex of an Indo-European equine sovereignty goddess!" Quite possibly the only pigeon-hole she would actually be flattered to inhabit.

Her formal training in fine art was limited to life drawing classes at Otis Art Institute and a BFA course at Mount Saint Mary's College – both in her home-town of Los Angeles. However, as she is the only child of two British artists, she considers herself to have received a privileged art education in a somewhat bohemian home, littered with marvellous books and crowded

*Faery Horse*
*9½ x 12½ inches. Pencil*

Simply an ethereal little horse which happens to be fluttering by…Horses appear in many mythological tales; their nobility and their affinity with our species have given them a central role in many races' spirituality and literature. Even when the horse appears as a creature as delicate and airy as a butterfly, its signifi-cation is archetypal

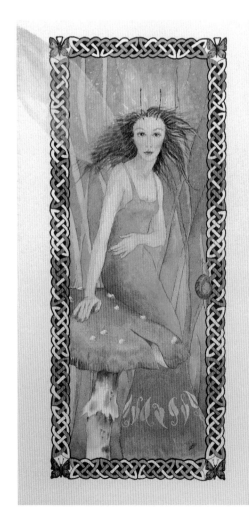

### Deirdre
*22½ x 28½ inches. Chinese ink, watercolour and gold leaf.*

This large piece takes its text from the novel *Deirdre* by James Stephens. The wonderful legend of Ireland's loveliest heroine includes this romantic meeting with the sons of Uisneac, the eldest of whom Deirdre – a woman truly in the celtic mode of feminine strength and willfullness – cajoles into eloping with her. In this passage, Deirdre is presented as a young girl encountering for the first time her own sensuality and independence.

### Duet for Harp and Horn

*6 x 8½ inches. Pencil and watercolour.*

This piece is a tribute, albeit somewhat irreverent perhaps, to the artist's ex-husband, composer and euphoniumist Jonathan Bulfin. Far from being intended as a portrayal of 'the brass-player as gnome', it is rather intended as a counterbalance to the humourous duets attempted by Jane and Jonathan; and surely one can appreciate that it is quite difficult for a harpist to hold her own against an instrument of the tuba family! This image seeks to redress the imbalance.

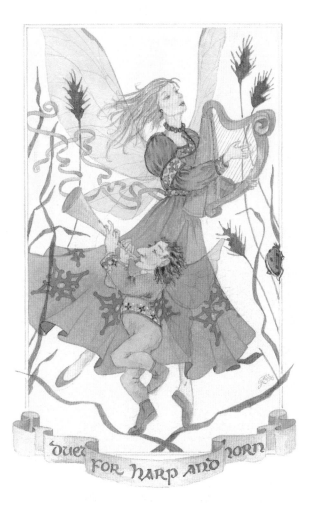

with canvases of Irish landscapes (painted in oils by her father) and illustrations of fairies, leprechauns and nursery rhymes (her mother's delicate watercolours). Early on she learned to appreciate the work of Arthur Rackham and Edmund Dulac, as well as Heath and Charles Robinson. Maxfield Parrish became an important influence, as did Norman Rockwell and Andrew Wyeth. The modern generation of painters of Faerie, headed by Alan Lee and Brian Froud, inspire her current work, as do the French painters Bruno Schmeltz and Catherine-Marie Alexandre.

The inspiration to draw and paint, however, comes not only from the images of other artists, but from the love of poetry, Anglo-Irish romanticism, mythology, and, above all, the works of J.R.R. Tolkien. Her academic studies have included epic and poetic literature in Old, Middle and Modern English, Old Irish and Medieval Welsh, Celtic Mythology, early English mysticism, the calligraphy of the early Middle Ages and the rich heritage of the manuscript tradition in Latin throughout Europe

In 2003 she moved to the Dordogne region of France. She works from her home in an isolated valley surrounded by vineyards, woods, lakes, and meadows – sometimes populated by soft-eyed brown cows, sometimes by deer or wild boar. Her companion, who is an heyoka (!), has offered her the greatest inspiration and has been the source of the light and harmony of her present style. Although continuing to practice the art of calligraphy and illumination, Jane concentrates now on her watercolours of fantasy subjects and has recently returned to her earlier medium of oils.

Her concern in her artwork, as in her academic studies (she is currently a doctoral student at the University of Bordeaux, her specialization being the role of the horse in American-Indian spirituality), is to celebrate with reverence the dignity, divinity, and sheer magic of the natural world, on all it levels –seen, sensed or perceived – with the wonder of the open-hearted child, the true mystic.

# RYUICHI TAKEUCHI

FOR THE LAST TWO YEARS, Ryuichi has been studying and developing his watercolour painting technique, though he still feels he has a long way to go. All the images presented here are made with watercolour paints using Cotman watercolour paper. Ryuichi sketches with B3 pencils and now works with the full range of 108 watercolours of Holbein. He seem to get through a lot of blue and Peacock Blue is the blue he likes best, perhaps because it is his birth sign colour?

Ryuichi works with a very slender brush. This comes naturally to him as growing up in Japan meant that from an early age he learnt how to use very fine writing and painting tools. The technique he frequently uses is wet-on-dry, at the moment he prefers the graduation to combine colours.

Ryuichi's creative imagination is always giving him ideas which he sketches on his art pad, carried at all times. "I love the originality and I have so many ideas, influenced by colours, ores, jewellery, and flowers which here in Japan are renowned for their vivacity and delicate shapes."

Once he has decided on an idea for his composition, he makes a more detailed drawing, colouring directly onto the rough sketch. The points Ryuichi cares about most when drawing are the eyes, They, along with the facial expression and the hairstyle, say everything about his image and what he feels – this is the hardest and most expressive part. "Strange, it is only

*"I love the originality and I have so many ideas, influenced by colours, ores, jewellery, and flowers..."*

**Blue Roll and Raspberry Roll**
*10 x 7½ inches. Pencil and Adobe Photoshop.*

✥ **Suzuran Lily of the Valley**
*7½ x 8 inches. Pencil and Adobe Photoshop.*

I'd had this idea for *Suzuran* for four years. I felt I was not getting the round small formation easily, so I kept putting this image aside and it took some time to finish this work. Suddenly I was inspired and could finish the work at last, thanks to my daughter who was born last year. Maybe living with a small round fairy daughter influenced me.

when this is completed that I can decide how to dress my fairy by sketching and designing nature's dress and filling it full of its richest colours."

Ryuichi is greatly influenced by the artist Yasuhiro Nakura whose work he respects greatly – it was his work that inspired Ryuichi to become a creative artist. Japanese doll artists are also a significant influence on Ryuichi. With modelling clay, the skilled doll makers create tender and delicate facial expressions. From this Ryuichi is able to combine the Orient style with the fairy folklore. Through his new images he hopes to inspire others with new connections and spiritual messages.

*Indicolite*
*14 x 10½ inches. Pencil and Adobe Photoshop.*

I wanted to express most of this fairy in straight lines. I thought it would make an interesting statement and I have had quite favourable comment on the design.

*Spinel*
*12½ x 10½ inches. Pencil and Adobe Photoshop.*

I had this vision of a fairy in deep red surrounded by silver and structures that had the physical quality of silver, thereby, emphasizing the fairy as a jewel in one of natures precious metals.

# Kim Turner

**ᘛ The Apple Blossom Faerie**
*16½ x 11½ inches. Watercolour.*

I think because I grew up enchanted by
the faeries of Cecily Mary Barker, I still
believe in the concept of 'flower faeries';
so this is another of my flower faeries –
the Apple Blossom Faerie…I kept the
colours soft and feminine, as the name
'Blossom', for me, evokes a 'soft and
pretty' faerie.

Since Kim's artwork was first published, she has
been working on her watercolour techniques
and challenging herself with the idea of 'form', by
attending live model workshops. She can't begin to
express their value to any artist, no matter how
confident they may be with the human form as
there is always more to learn.

Kim has also spent a great deal of time
researching colour theory, knowing that colour
knowledge is a fundamental tool when trying to
successfully master the 'push and pull' of creating
believable depth and form on a flat surface. She has
a determination to master her craft and a strong
interest in the introspective side of the faerie world,
which is why her images tend to be internal
dialogues, rather than interactions with the
external world.

Kim likes the notion that her illustrations are
moments in time that she has been able to capture
with amenable faeries – that it has been an
interaction on both parts; she has painted, they
have posed; she has admired, they have agreed.
"Inspiration can come from anywhere, anytime – it
might be a colour or a lyric or a look on a face that
drives you single-mindedly to create a 'world', and
equally true, you can have periods where nothing
inspires and that can be as frustrating as finding
too much."

Her recent work has largely been for commissions
in Australia. There is a great faerie interest in Australia
and Kim can see faerie in a lot of folk – as an artist
there is always something that she can feature or enhance to create 'a look'.

Working almost exclusively on Arches hot pressed watercolour paper,
Kim prefers the smooth surface paper, as she doesn't like the texture of the
cold pressed to interfere with smooth skin textures. She works by building
up layer upon layer; finding that washes can settle in the tooth of the paper,

*"Kim likes the notion that her illustrations
are moments in time that she has been able
to capture with amenable faeries."*

creating unpleasant skin tone effects. She has stuck faithfully to her Derwent Watercolour Pencils, she uses two or three sets at a time, one is always for making washes, the others sets are kept as sharp as possible, for the finer details that go on after the layers have built up enough. She has also started to use pastel pencils as well; they tend to sit quite well on top of the finished watercolours. Take a look for yourself and see whether you find her faeries amenable!

### ✿ *The Faerie Casey*
*16½ x 11½ inches. Watercolour.*

This faerie was inspired by a little friend of mine by the name of Casey – one afternoon we took some photos in the rainforest, and this was one of the images that came from that session. She evolved into the kind of beautiful, pensive faerie that would be found flitting around in the shadowy recesses of the rainforest…

# JOSEPHINE WALL

JOSEPHINE WAS BORN in Surrey, England in 1947 and her family moved to Dorset when she was fourteen. Her first employment, after three years at Bournemouth Art College, was at Poole Pottery, where she painted the dynamic and boldly coloured designs of the now famous Delphis ware – highly collectable pieces which achieve high prices at auction.

Although she has an interest in all forms of craft, her first love is painting. Since childhood, Josephine has had a passion for light and colour, fantasy, and visual storytelling – the life of a painter was clearly her destiny.

She lives contentedly with her husband at 'Wisteria Cottage', where she works in a purpose-built attic studio. The walls are covered with a web of wisteria, cascading gorgeous flowers – hand painted of course! Josephine is convinced that working under the pyramid shaped roof provides a constant source of inspirational vibes, aiding her creativity! The rest of the cottage also displays her artistic nature, a woodland scene with butterflies in the kitchen, flowers and birds on the furniture and even more wisteria on the glass doors in the living room. Even the garden doesn't escape her touch, as she loves designing unusual features and creating an abundance of colour, with a slight bias towards the Victorian style.

Over the years her passion for painting has moved her from ordinary landscapes and seascapes, towards fantasy and surrealism. She is influenced by the illustrative talents of Arthur Rackham (especially his fairies and trees), the romanticism of the Pre-Raphaelites, and the surrealism of artists such as Magritte and Dali.

Josephine uses Cryla artist quality, acrylic paint, as it is quick drying. To

### Tree of Reverie
*30 x 40 inches. Acrylic.*

Somewhere deep within an enchanted forest there is a magnificent and special tree. Those who stop to admire it soon feel the need to take a nap. Once asleep the maiden imagines herself to be drifting amongst the clouds. Her mind is filled with dreams of a bygone age. Are these dreams of events she has experienced in another life, or are they perhaps visions trapped within the branches, collected by the tree over many centuries?

### Caught by a Sunbeam
*24 x 30 inches. Acrylic.*

Nestling her head on a cobweb pillow the pretty fairy drifts into slumber, after a hectic night of revelry, at a celebration of spring party with the elves and pixies. Many of her friends are hiding nearby!

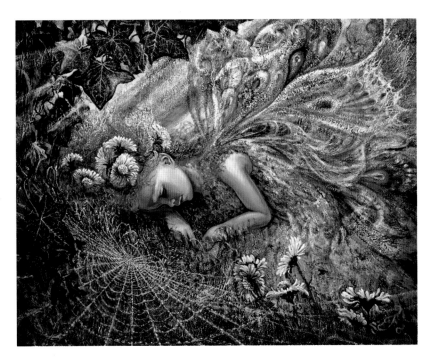

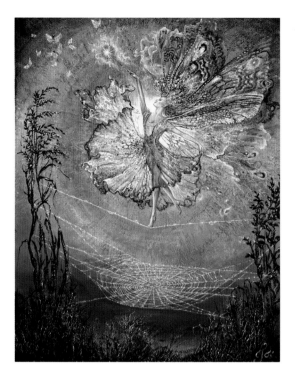

### ⚘ Flight of the Lynx (pages 100–101)
*30 x 40 inches. Acrylic.*

Symbolizing an affinity between human kind and the animal kingdom, the companions embark on a nocturnal flight, with no other purpose than the pure joy of soaring high above the sleeping world. Above them galleons dip their nets into the night sky, trawling for stars.

### ⚘ Silken Spells
*24 x 18 inches. Acrylic.*

This fairy loves to whirl and pirouette on the finest of cobweb silk, especially when moonbeams reflect their rainbow colours all around her gossamer wings. After her dancing is done, the wind carries her home on a playful breeze. Each miracle of nature's beauty fills her heart with joy.

create unusual textures imitating bark, wings, foam and lace, she uses a palette knife. This versatility however also enables her to use layers of thin washes for smooth areas such as skin, to build up luminosity. Using a very small brush she finishes off the fine detail. She paints on canvas or Masonite.

Much of the inspiration for Jo's mystical images comes from her close observation of nature and her interest in its preservation, a subject very close to her heart. Though she often strives to impart a message in her work she also hopes to inspire in her audience a personal journey into the magical world of their own imagination.

As with most artists, Jo is often asked where she gets her ideas from and for her they come from anywhere and everywhere. Luckily, Jo is never short of inspiration; in fact she feels it is a race against time to produce all the images that she has conceived. It takes her what she considers a lifetime to paint one of her pieces, because she has painted since she was a child and her work has constantly evolved and matured until the current image is created. Each painting actually takes an average of two to four weeks, depending on size and subject.

Her work can now be found all over the world in many different forms including, cards, stationery, puzzles, journals, bookplates, back-to-school

### Sadness of Gaia ⚘
*30 x 40 inches. Acrylic.*

The Earth Goddess looks on sadly, aware that our human weaknesses will mean many years of education to prevent the ruin of our precious world. The contents of her wings symbolise all the creatures that need protection. As always *Gaia* will be there to listen and to comfort, bringing with her the rainbow of hope.

The clouds are gathering around our world but she knows she must be strong and work to rectify man's errors, in the belief that he will one day understand that our precious earth deserves our protection. Let us hope that one day soon *Gaia* will look upon the earth and be satisfied that her lessons have been learnt!

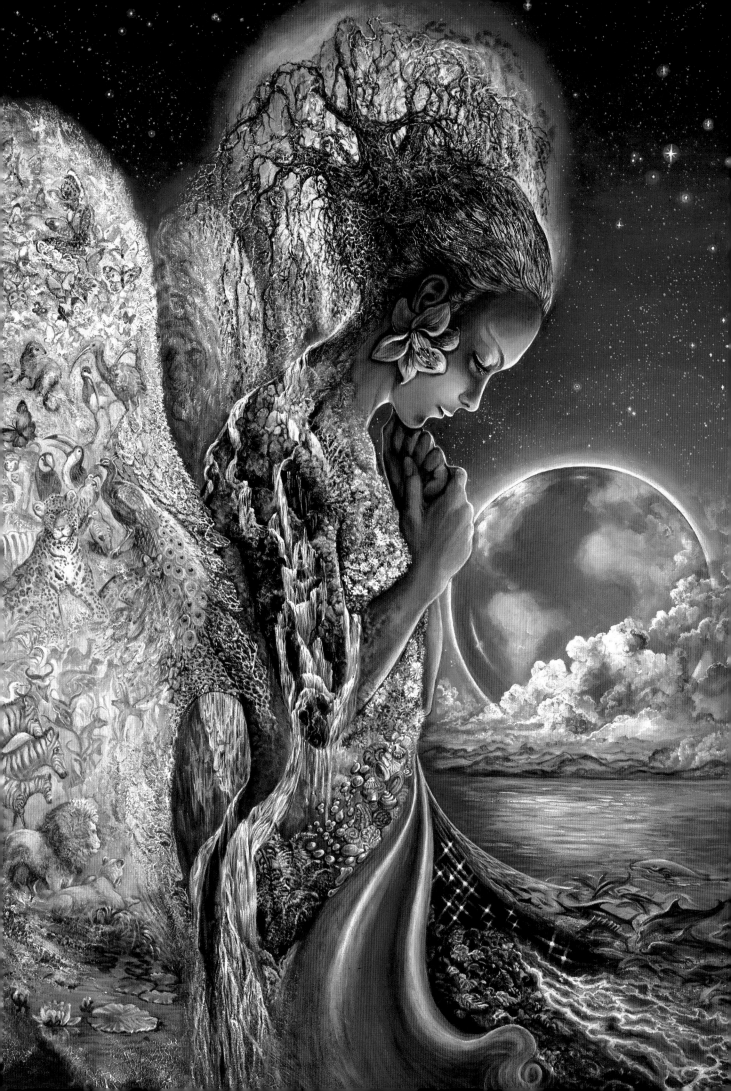

products, mugs, needle point kits and posters, as well as her own limited edition prints.

"Painting is more than a career to me! It is an all-consuming obsession and love of colour and form, in fact if I am away from my easel for too long, I become restless and anxious to paint again."

It would seem that in these troubled days and the high pressure of life in general, more people than ever are seeking the escapism of fantasy and surrealism. In addition to an annual London exhibition held by the Society for Art of the Imagination to which Jo belongs, her work can be found in galleries all over the south of England, but most of her success is in the U.S.A. Look out for a book soon to be published titled *The Fantasy World of Josephine Wall*, containing much more information and many images, some of which have never been seen. Update yourself with Josephine's work on the internet at www.josephinewall.co.uk.

**Bubble Flower**
*24 x 30 inches. Acrylic.*

From her enchanted flower of bubbles, the fairy blows fragments of fairyland into the mortal world, reminding us that a touch of magic can make any day more beautiful.

Visions of a flying galleon, a cat with wings and a magnificent unicorn, are carried on the wind to far off places. Encased in their delicate multicoloured orbs, they float effortlessly, and yet like our own fantasies are so vulnerable, and can be gone in an instant.

mjw
2003

# Maria J. William

M ARIA J WILLIAM came to New York from eastern Europe in 1994, moving last year into Bay Ridge, an area of Brooklyn, New York City. The proximity of the ocean is a vital influence on her creativity and she now has two of her favourite environments – the city streets and the beach – in close proximity.

Besides her art, most of her time is spent bringing up her four year old son, so she doesn't get much time to travel. However, she has always been quite an indoor fairy when it comes to venturing out into the big world. Her first big art-related appearance occurred in June 2005 when she was the guest of honour artist at Duckon 2005, an annual fantasy and science-fiction convention in Naperville IL .

One of the biggest changes was probably her first discovery of watercolour paints. Throughout her life, from the time she first picked up watercolours as a kid, she always hated them. Then all of a sudden, practically overnight, she was in love. "I love just how different it is from oils and pencils which are my two favourite mediums to date. It has taught me as much about different media, as it did about myself as an artist."

A second change in Maria's technique is that she's thrown away all her art-related books well, not literally. "I never actually throw away books. I've realized that I'm at my best in work when I follow my heart, no charts, no formulas and no rules!" Maria compares her style in the words of English artist John Opie (1761–1807); when asked what he mixed with his colours, he replied "I mix them with my brains, sir." Maria is trying to be more risky in how she works, using bolder colours, definitely new imagery, stranger

**Dreamcatcher**
*11 x 14 inches. Watercolour and coloured pencil.*

A silly little piece that was done mostly for the sake of playing with some stylized elements as well as my new watercolour pencils.

**Moonlight Anthem**  ↩
*8 x 13 inches. Oil paint.*

A small, simple piece that was inspired by modern Japanese music, in particular the singer/songwriter Arai Akino.

### Profusion
*15 x 20 inches. Oil paint.*

I woke up one day, and this image was in my head. With this piece I wanted to convey the feeling of carefree joy, happiness and serenity, which I believe to be the very quintessence of the spirit of fairies.

figures and settings. Sometimes it just comes out like a stream of consciousness, and even Maria can't explain what it means. She actually finds it quite fun to put such pieces up on display, and to see the reactions of viewers and the theories they come up with.

A huge fan of fantasy films, Maria believes they definitely inspire her as far as emotion goes and may have influenced the changes her fairies have undergone, varying from piece to piece. Mostly she's been trying to make them look somewhat unorthodox, make them seem like characters with some sort of mystery and a story behind them

In reality, Maria is actually quite sceptical, not believing in horoscopes, superstitions, psychics and other mystical things. "I'd like to call myself an open-minded empiricist. I only believe what I can see with my own eyes – which, for an artist like myself, is quite ironic." Maria's art is not really a vehicle for her own personal experiences. It is more like a form of escapism. But at the same time she is the kind of person who's always open to possibilities. If she awoke one morning and saw a fairy sitting on her drawing table she wouldn't think she was going crazy! Instead, Maria is more likely to think, "Look at that, that's amazing!", followed by, "Now quickly, before it flies away, where did I put my drawing pad?"

### Pollen
*11 x 14 inches. Coloured pencil.*

This drawing was inspired by pre-Raphaelite art, in particular Waterhouse and Rossini.

# ARTIST WEBSITES

**ALAN LEE**
Website: http://www.alan-lee.com

**DAVID RICHÉ**
Website:
http://www.fairiesworld.com

**JOHN ARTHUR**
Website: www.johnarthur.com
Email: john@johnarthur.com

**JAMES BROWNE**
Website: www.jamesbrowne.net
Other sites: www.elves-pixies.com
Email: james@jamesbrowne.net

**JASMINE BECKET-GRIFFITH**
Website:
www.strangeling.com
Email: jasmineToad@aol.com

**JACQUELINE COLLEN-TARROLLY**
Website: www.toadstoolfarmart.com
Email:
jacqueline@toadstoolfarmart.com

**RENEE BIERTEMPFEL**
Website: www.autumngrove.org
Email: reneebiertempfel9@hot-mail.com

**JESSICA GALBRETH**
Website: www.enchanted-art.com
Other sites: www.fairynight.com
www.fairyvisions.com
Email: fairyvisions@aol.com

**LINDA BIGGS**
Website: www.fairieforest.com
Email: info@fairieforest.com

**SCOTT GRIMANDO**
Website: www.grimstudios.com
Email: scottgrimando@verizon.net

**AMY BROWN**
Website: www.amybrownart.com
Other sites: www.fairyfantasia.com

**VIRGINIA LEE**
Website: www.virginialee.net
www.surreal-artist.co.uk
Email: virginialee@mwfree.net

**HAZEL BROWN**
Website: www.faery-art.com

**NATALIA PIERANDREI**
Website: www.nati-art.com
Other sites:
www.flowerfaeries.com

**MYREA PETTIT**
Website: www.fairiesworld.com
Other sites: www.fairystencils.com
www.fairy-pictures.com
Email:
myrea.pettit@fairiesworld.com

**JEFF SPACKMAN**
Website: www.spackmanart.com

**MARC POTTS**
Website: www.marcpotts.com

**PAULINE STUCKEY-CASSIDY**
Website: www.paulinastuckey.com
Email:
paulina@paulinastuckey.com

**STEPHANIE PUI-MUN LAW**
Website: www.shadowscapes.com
Email:
stephlaw@shadowscapes.com

**JANE SULLIVAN**
Website: www.fairyfonts.com

**LINDA RAVENSCROFT**
Website:
www.lindaravenscroft.com
Other sites:
www.duirwaighgallery.com
Email: linda@ravenart.fsnet.co.uk

**RYUICHI TAKEUCHI**
Website:
http://members.jcom.home.ne.jp/ryu
Email: ziki.lai@ro.bekkoame.ne.jp

**COREY J. RANDALL**
Website: www.faerieportraits.com
Email: Siege3@juno.com

**KIM TURNER**
Website:
http://home.austarnet.com.au/
moiandkim
Email: faeriegirl@austarnet.com.au

**ANN MARI SJÖGREN**
Website: www.fairypaintings.com

**JOSEPHINE WALL**
Website: josephine.wall@virgin.net
Email: www.josephinewall.co.uk

**Wenche Skjöndal**
Website: www.wencheskjondal.net
Email: wencheskjndal@yahoo.se

**MARIA J WILLIAM**
Website: www.mariawilliam.net
Email: maria@mariawilliam.net

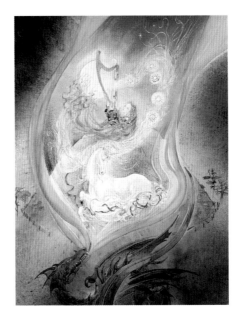

# ᴀCKNOWLEDGEMENTS

David Riché would like to thank the following people who gave so much support with this book:

This volume would not have been possible without the continued support of all the contributing artists, whose careers we have followed with interest since the success of our first book *The Art of Faery* (2003). We were able to welcome and include here the work of new and exciting artists whose work demonstrates the passion of the fae, my thanks to all of you for your cooperation and encouragement.

I am indebted to Alan Lee for his supporting our visionary faery artists of the 21st century. Since his first book *Faeries* was published over 25 years ago Alan has established himself as one of England's pre-eminent book artists, creating exquisite watercolour paintings for, among other works *The Hobbit* and *The Lord of the Rings* for which he received a well-deserved Film Academy Award in 2004 for conceptual design. That Alan's vision has been perpetuated by those artists within is testament to his artistic genius, and the meaningful pleasure of his influential work has given so much creative inspiration to so many, with his authoritative understanding of middle-earth and the world of faery.

I would like to thank Brian and Wendy Froud for their continued encouragement and support in matters Faery. Per Arne Skansen for his research and help in Sweden with Ann Mari Sjogren and her illustrations. Izumi for her Japanese /English translations and communication with Ryu Takeuchi, the staff at Collins and Brown, Chris Stone and Miranda Sessions for their support and enthusiasm and book designer Malcolm Couch. Rachel Dursten for the text of her poem Keirsten and the faeries used by Myrea Pettit with her images. My web guru Ray Danks and Steve Clutty for their support skills in my studio. Not least the many new emerging artists whose new and varied faery art has not been able to be included in the space available here be encouraged to continue with your work, the world needs you.

*While the faeries dance in a place apart,*
*Shaking their milk-white feet in a ring,*
*Tossing their milk-white arms in the air:*
*For they hear the wind laugh, and murmur and sing*
*Of a land where even the old are fair,*

*Excerpt from The Faeries Dance, William Butler Yeats*